Spaniels

WORK, REST AND PLAY

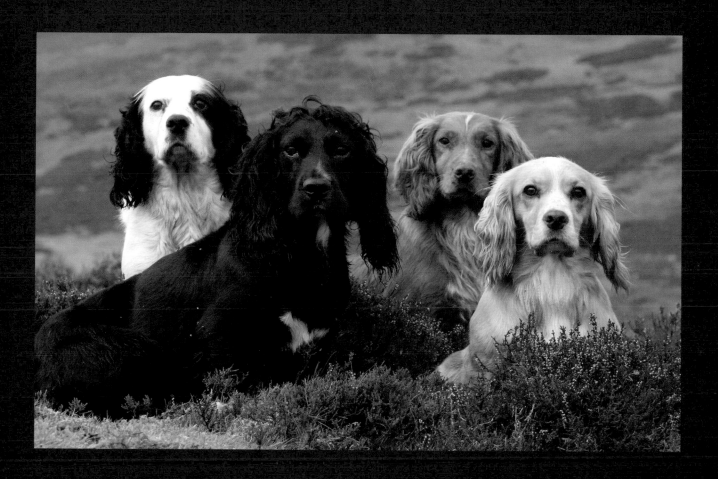

Photographs and text by
NICK RIDLEY

Quiller

Dedication

This book is dedicated to two very good friends, Andrew and Fiona Robinson of Whaupley Gundogs. They have given me the opportunity to witness spaniel work at its highest level and to experience the joy of shooting rabbits over some first class Cocker spaniels. I must also thank them for their help and co-operation in arranging numerous photo shoots in some of the most spectacular parts of the North Yorkshire moors.

First published in the UK in 2009
by Quiller, an imprint of Quiller Publishing Ltd

British Library Cataloguing-in-Publication Data
A catalogue record for this book
is available from the British Library

ISBN 978 1 84689 061 1

Printed in China

Quiller

An imprint of Quiller Publishing Ltd
Wykey House, Wykey, Shrewsbury, SY4 1JA
Tel: 01939 261616 Fax: 01939 261606
E-mail: info@quillerbooks.com
Website: www.countrybooksdirect.com

Spaniels

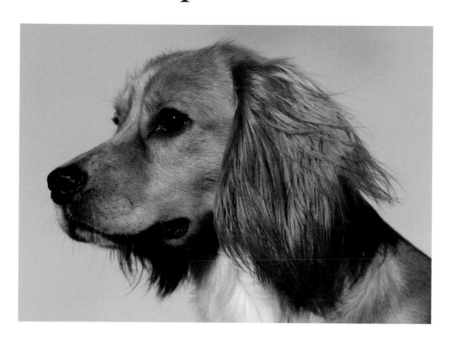

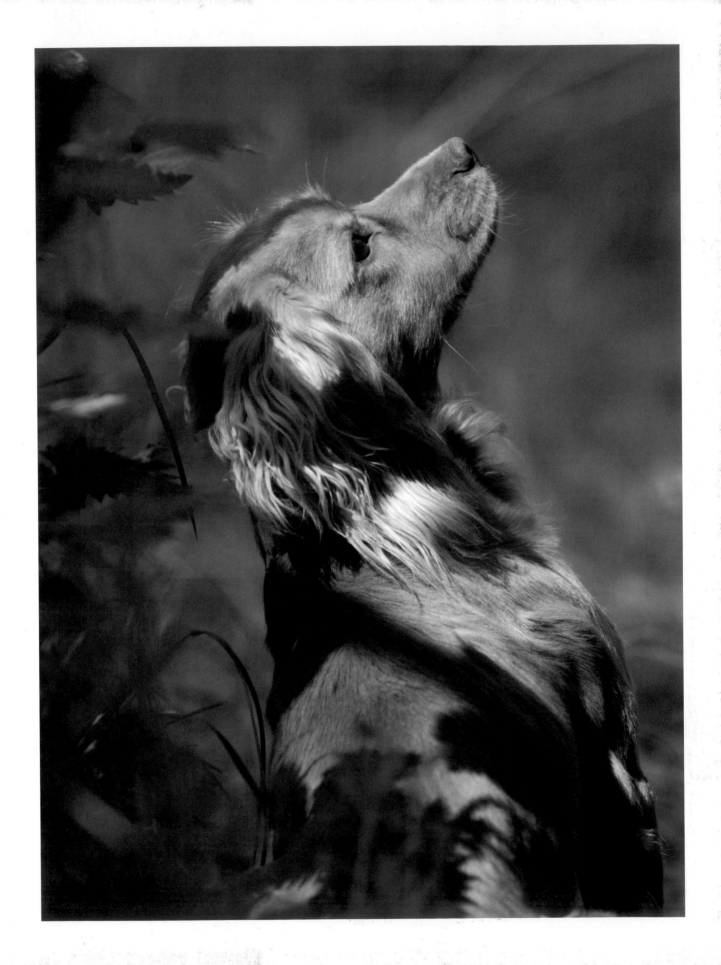

Contents

Introduction 6

1 The Beginning: Puppies 12

2 Come On In: The Water's Fine 36

3 Spaniels and Rabbits: The Perfect
Combination? 54

4 Spaniels In The Field 68

5 The Versatile Spaniel 98

6 The Portrait Spaniel 118

INTRODUCTION

Anyone who owns or indeed has ever owned a Cocker or Springer spaniel will tell you that no matter how you feel as you struggle to get out of bed in the morning within seconds of being greeted by a madly bouncing dog with floppy ears and more often than not a stupid look on its face it is nigh impossible to stay miserable for long!

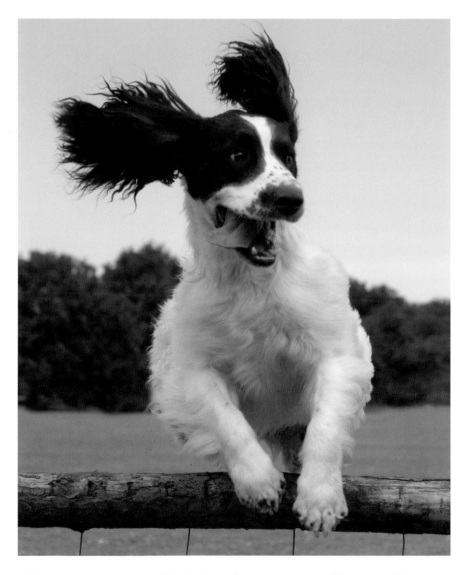

...How can you stay miserable for long when you are greeted by a set of floppy ears and a stupid look on his face!

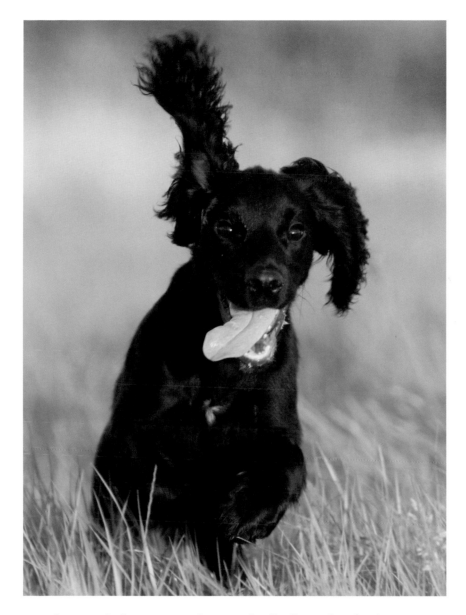

Anyone who has ever owned a spaniel will tell you that they have an exuberance for life that is hard to match in the canine world.

Spaniels have an exuberance for life which is hard to match in the canine world but not only are they a happy-go-lucky kind of dog they are also truly versatile. Springer and Cocker spaniels were originally bred to hunt, flush and retrieve game for the Gun and they still excel in the shooting field. However in recent years they have turned their 'paws' to other highly skilled activities. Spaniels have highly developed noses and Man has trained them to hunt out explosives, drugs and in recent years they have even been trained to detect cancer cells in human urine...remarkable. Many people have heard about Guide Dogs for the Blind and generally spaniels are not very well suited to this kind of work but Hearing Dogs for the Deaf have found that spaniels, especially Cockers take on the role of their recipient's 'ears' very well indeed.

As a professional dog photographer I have a passion for photographing these happy, sometimes mad little dogs. I heard someone once describe a Cocker spaniel as being like a 'bumble bee in a jam jar!' I have spent the past twenty-five years with spaniels in my life. Meg was a very leggy (and not very well bred!) working Springer and she introduced me to the world of gundog training and shooting. I can still remember as if it was yesterday the first rabbit I ever shot over her. She has long gone to the kennel in the sky but it wasn't long before the spaniel bug bit again and now I have two working Cockers.

Sweep and Harry are as different as can be not only in looks but also in 'workability'. As Gundog Editor for the *Sporting Shooter* magazine I have written a monthly diary of Sweep ever since she was born and she even has her own blog! She regularly gets her fans coming to see her at the various country shows we attend during the year. Sweep is very small for a Cocker and her hunting skills leave a bit to be desired but she loves to retrieve and despite her small stature she still manages to retrieve lively cock pheasants. Harry is a different ball game all together, he has an exceptional pedigree, is longer in the leg and just seems to flow over the ground. He is still very young but I do have high expectations for him, I just hope I can do his ancestry justice.

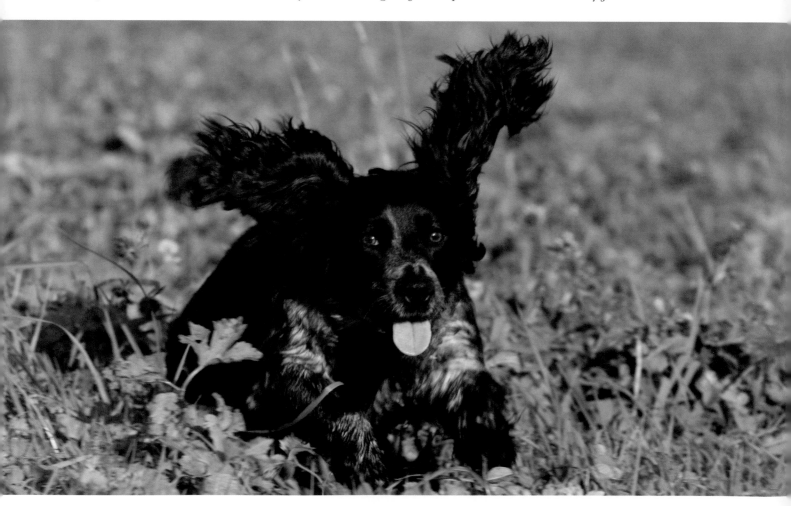

Sweep is one of my own two working Cockers. She is only ten inches high, has her own blog and constantly makes me smile.

OPPOSITE: Harry is still only young but he is already showing that he has the potential to be a good all-round shooting dog.

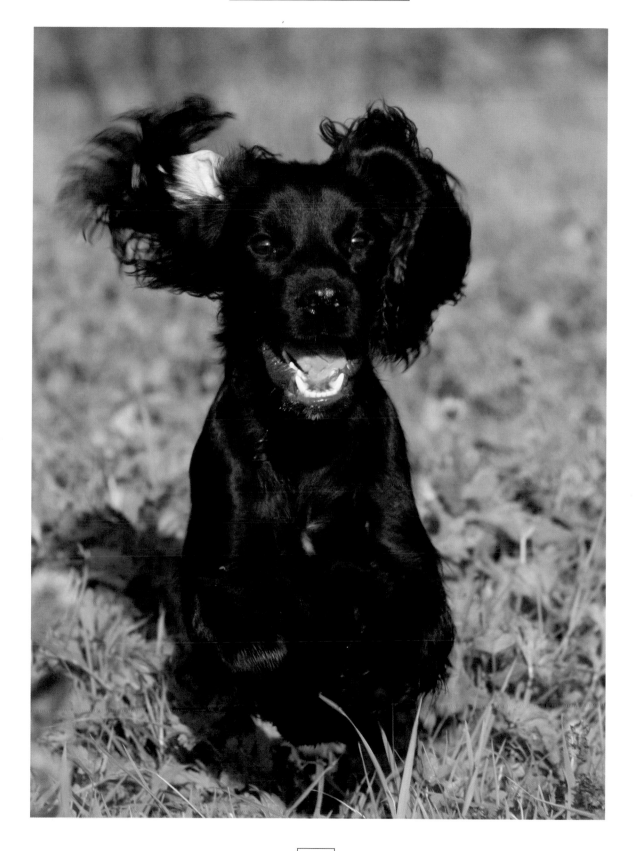

Not so long ago I was having a conversation with a well known spaniel man and we got on to the subject of what groups of animals and birds are called, things like a gaggle of geese or a charm of goldfinches and before long we started on the dog world. It wasn't long before we settled on a 'chaos of cockers' and 'spasm of springers'. Spaniels are the clowns of the dog world, one minute they are charging around like lunatics, the next they are upside down, fast asleep looking as though butter wouldn't melt in their mouths…love them or hate them…they *will* definitely make you laugh.

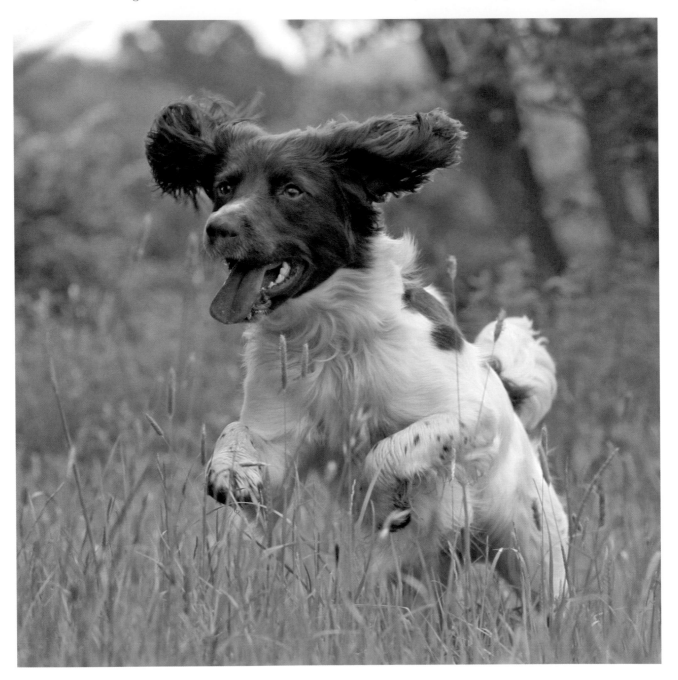

Spaniels are the clowns of the dog world — one minute they are charging around like lunatics and the next…

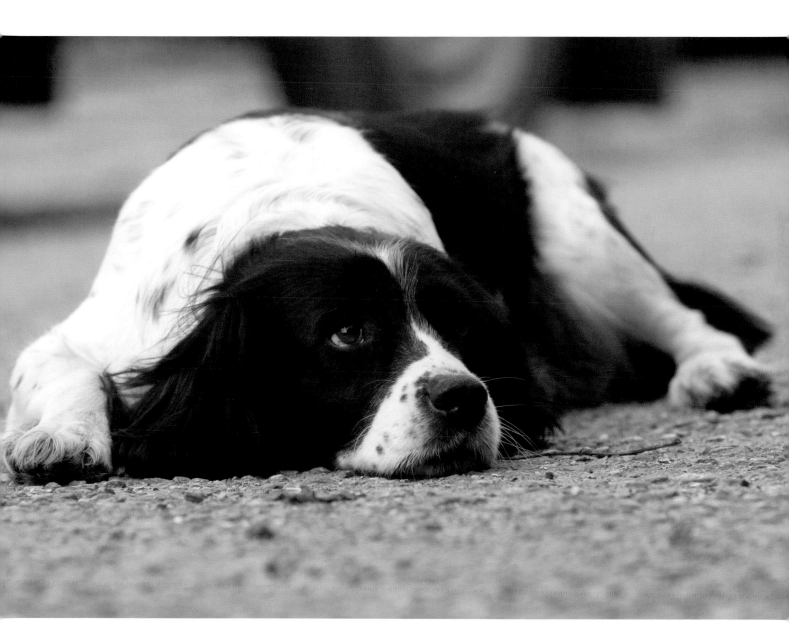

...they look as though butter wouldn't melt!

1 THE BEGINNING: PUPPIES

Now I have a confession to make…I am addicted to photographing spaniel pups. There surely can be no better way to spend a few hours than rolling around the floor with a camera capturing the antics of a lively bunch of Cocker or Springer puppies. Cocker spaniels come in a variaty of colours ranging from liver, black and golden through to lemon, blue and liver roans and the less frequently seen tri-colour (black, tan and white) and the amazing thing is how their colours change as they get older. My own working Cocker Sweep was black and white when I first saw her at five weeks old and now she is blue roan with very little white. Incidentally the bitch was liver and white and the dog lemon…how does that work then?

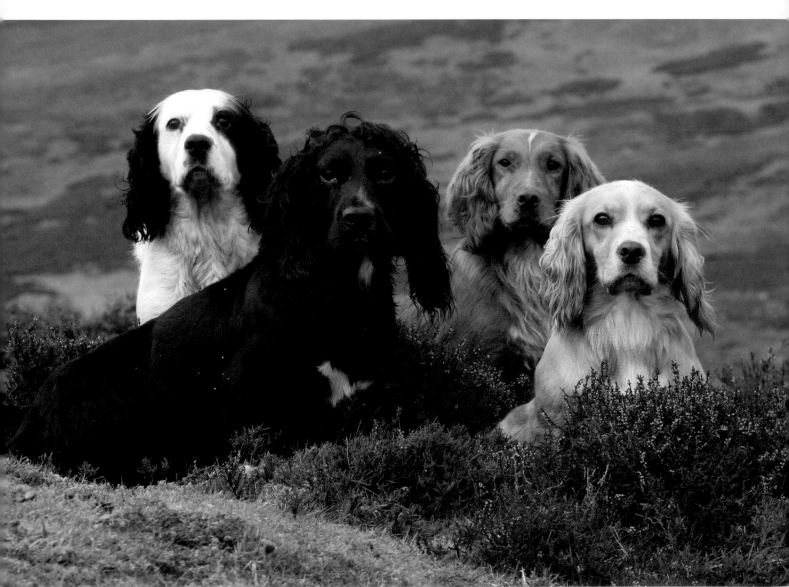

Cocker spaniels come in various colours ranging from liver, black, golden, blue and lemon roans…

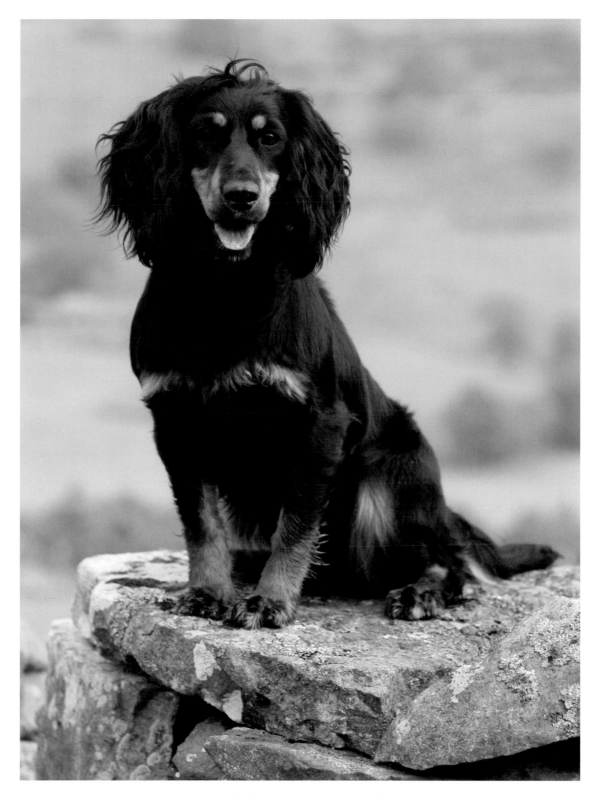

...to the less frequently seen tri-colour.

Photographing any breed of puppy can be exasperating and at times quite arduous (especially as you get older!) and only last week I spent a very frustrating afternoon trying to get some stock images of a six week old litter of Cocker pups. The previous few days had been quite wet so they hadn't been out of the kennel so logically I thought when they did see grass for the first time they would be a little apprehensive of their new surroundings and this would give me plenty of time to get my pictures...how wrong could I be! I have a 'golden rule' when taking images of dogs and that is I always get down to the dog's eye level...have you ever tried this with seven pups wanting to climb on your head, chewing your camera strap and licking the front of a £2000 lens? Not very productive but great fun!

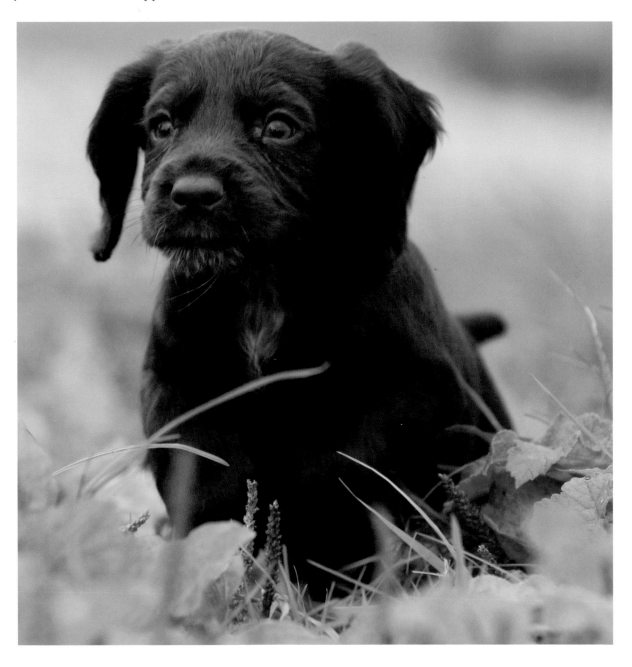

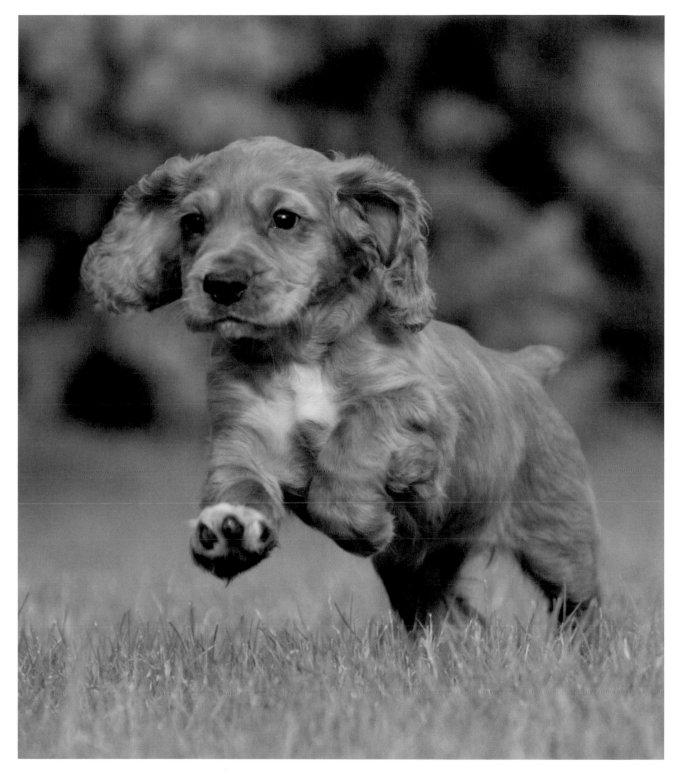

OPPOSITE AND ABOVE: Photographing any breed of puppy can be hard work but this litter of Cockers had me pulling my hair out!

Eventually they started to settle down and I managed to get a few images and before long I found myself wondering if we could squeeze another Cocker into the Ridley household.

My daughters are both at university and after all Cockers are only little dogs. I had nearly convinced myself that it wouldn't make a lot of difference but just then I saw my jacket being dragged all over the place by a particularly cute liver roan pup and I decided there and then that two spaniels is quite enough.

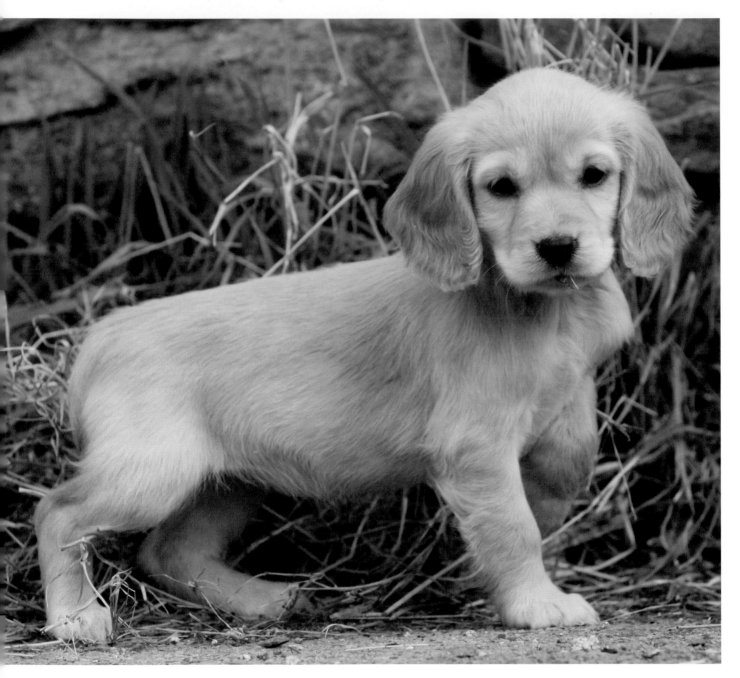

I was sure I could fit just one more Cocker into the Ridley household…

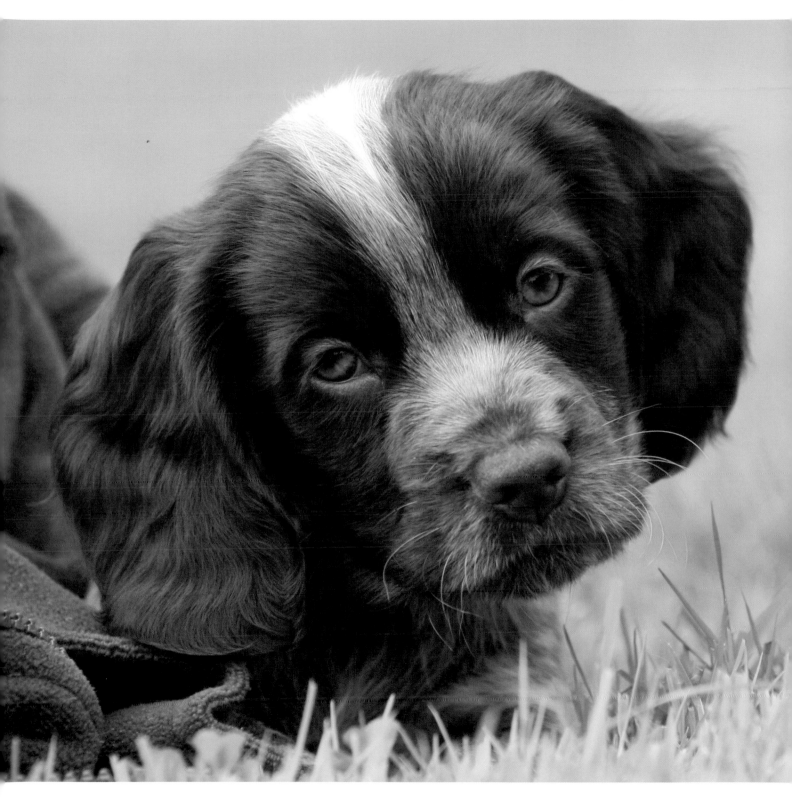

A picture of innocence, but that was after this little liver roan Cocker pup had dragged my jacket all over the garden!

One of my very first commissions was of a litter of Springer pups and I wanted to photograph them in an old barn and they thought that was great as there were plenty of bits of straw and lumps of dried cow dung to play with. It took quite a long time to get them settled but eventually I came up with a plan. I found an old railway sleeper and put the pups behind this and fortunately it created a barrier and stopped the pups from running over towards me, and it just gave me long enough to take the pictures. I have to admit the pups were cute but I was totally exhausted by the time I had finished.

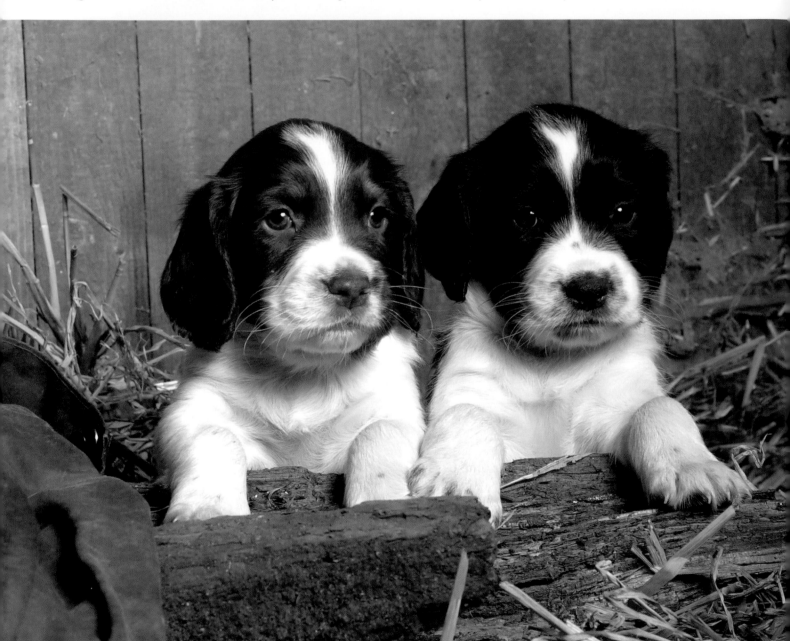

ABOVE AND OPPOSITE: One of my very first commissions was a litter of Springer spaniel pups...it took a bit of thought and ingenuity to keep them in place.

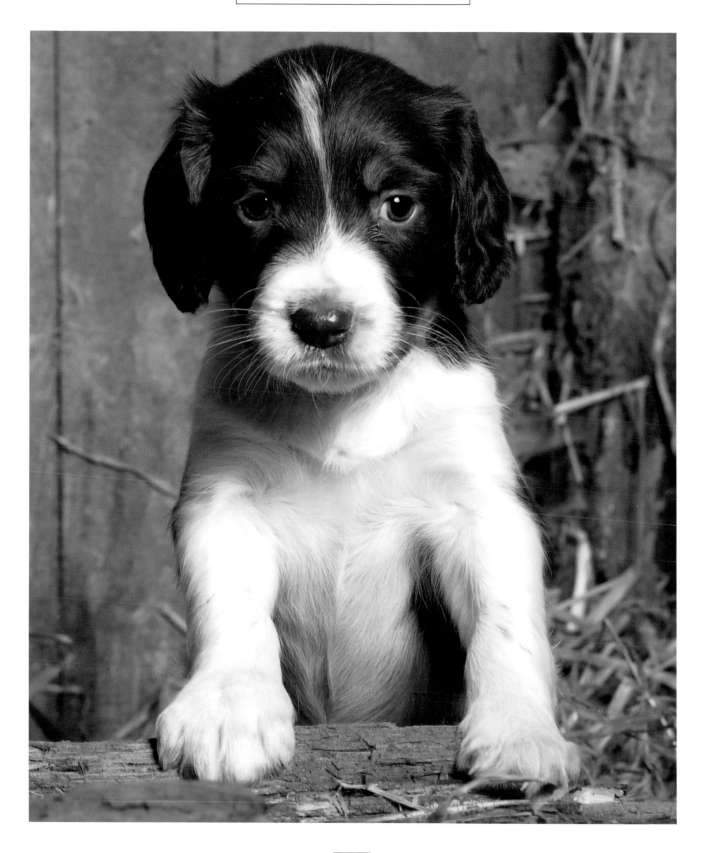

Of all the hundreds of registered dog breeds the difference between the working bred lines and the show bred lines is most pronounced in the Cocker and Springer spaniel and this can even be seen in young pups. I certainly do not want to get in to a debate about show lines and what the breeders may or may not have done to the working attributes of the breed but the physical difference is quite significant.

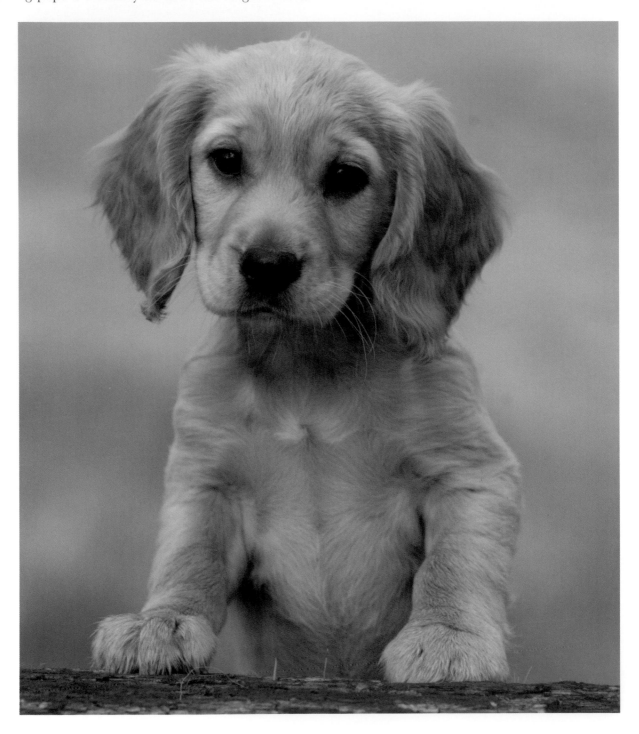

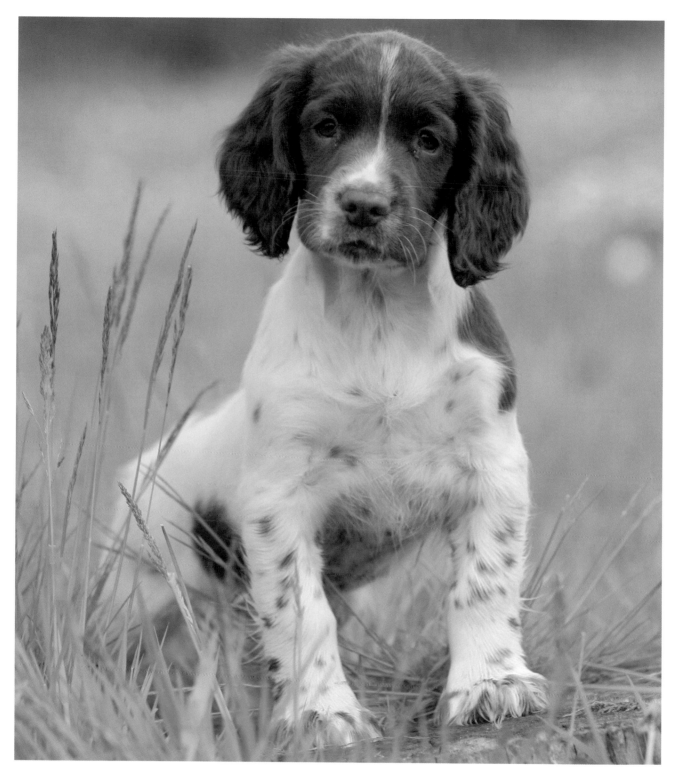

OPPOSITE AND ABOVE: These working bred Cocker and Springer pups have a very different shape to their show bred cousins...

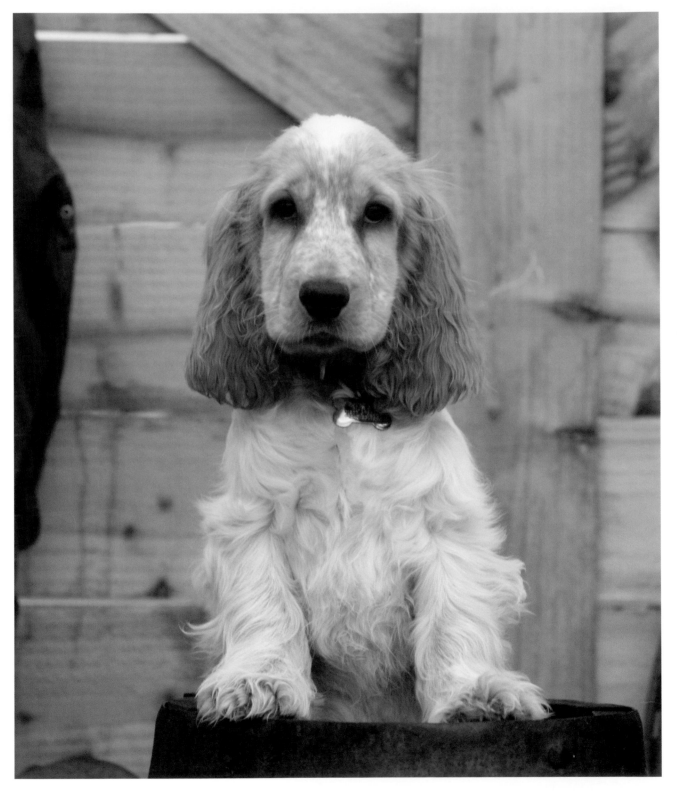

ABOVE AND OPPOSITE: These show bred Cocker and Springer pups have longer ears and a more domed head.

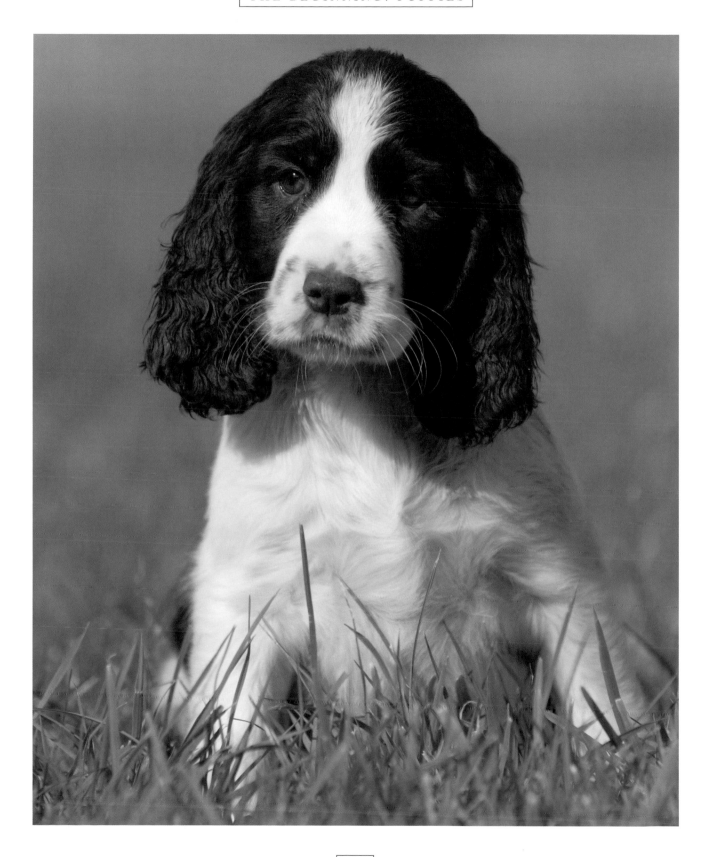

A few years ago I was commissioned to photograph a litter of show line Springer pups and I have to say what a smart bunch of pups they were. They looked very different from their working relatives having longer ears and a more domed head, but they still retained that natural desire to retrieve, albeit an old plastic flower pot!

One thing the owner did want was to have all six pups in a group. Now I consider myself a fairly competent dog man and I'm pretty good with a camera but even I knew this was a tall order, however as they say 'where there's a will…there's a way' and my computer was the way! I marked a place on the grass and as the owner placed each pup on the marker I took the picture, once back in the 'digital darkroom' I merged the six individual images into one panoramic photograph which now proudly hangs above the owner's fireplace…now that is what I call lateral thinking!

OPPOSITE: Despite being bred for the show ring these two pups still have the natural desire to retrieve.

A bit of lateral thinking and few hours in front of the computer 'created' this unique panoramic picture of a litter of show Springers.

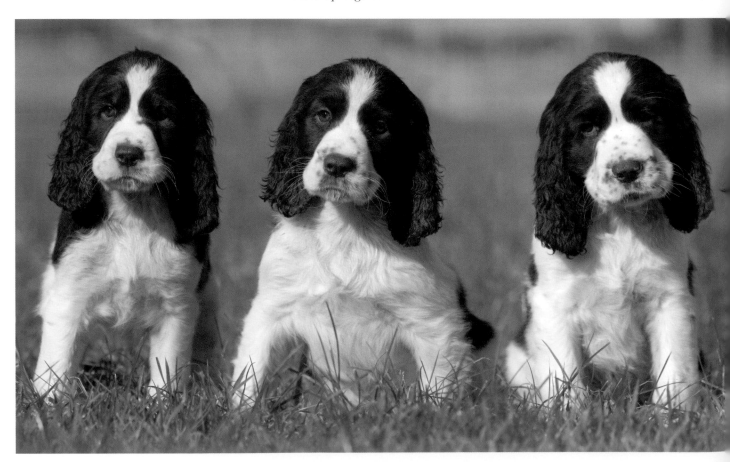

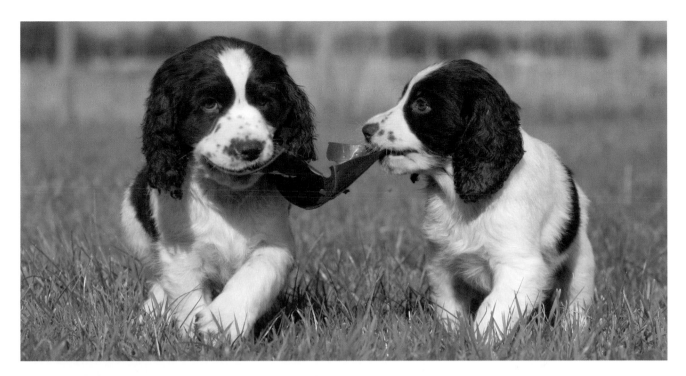

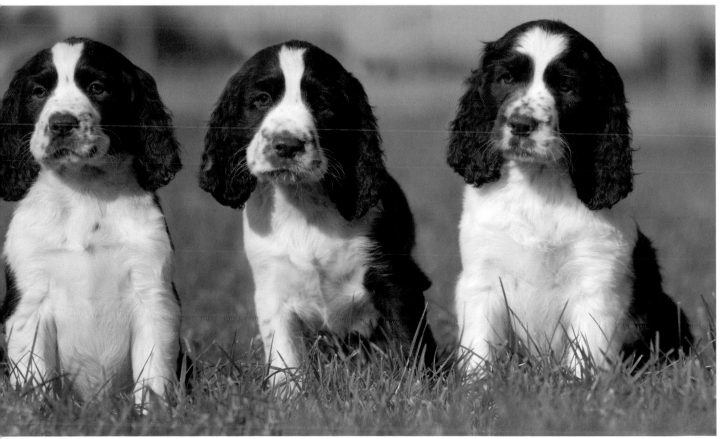

Watching a group of spaniel pups is a bit like watching a group of young children in a school playground. You get the shy one that hangs at the back of the crowd, you get the bully that just wants to fight with everyone else and there's the sporty one which runs and runs just for the shear pleasure. One thing I have never been able to work out is why spaniel pups have such a mad look on their faces when they run and then there are the ears. I have a theory… and that is when a spaniel pup is born, their ears are genetically programmed to reach their full size within a matter of weeks and then the rest of the body takes a year or so to catch up, why they don't spend most of their formative weeks and months tripping over I'll never know.

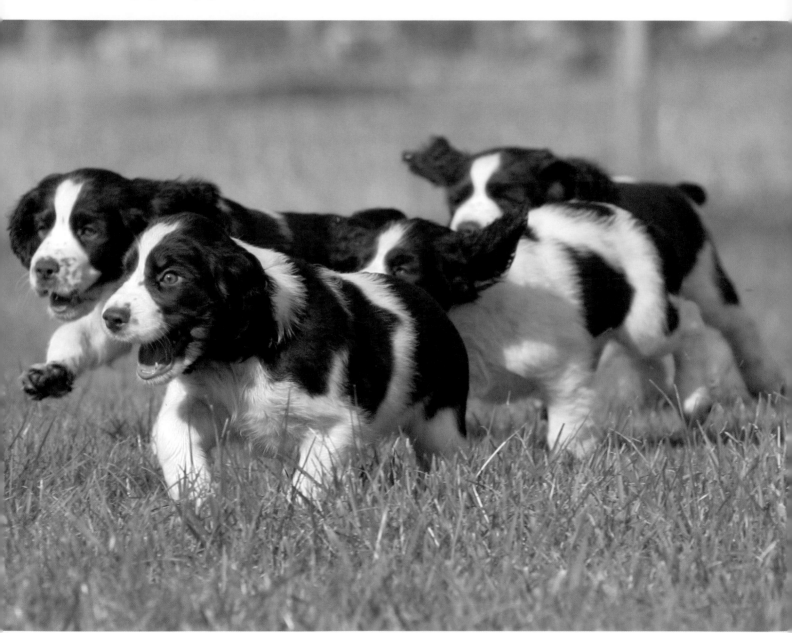

ABOVE AND OPPOSITE: There is definitely a look of madness when a spaniel runs…

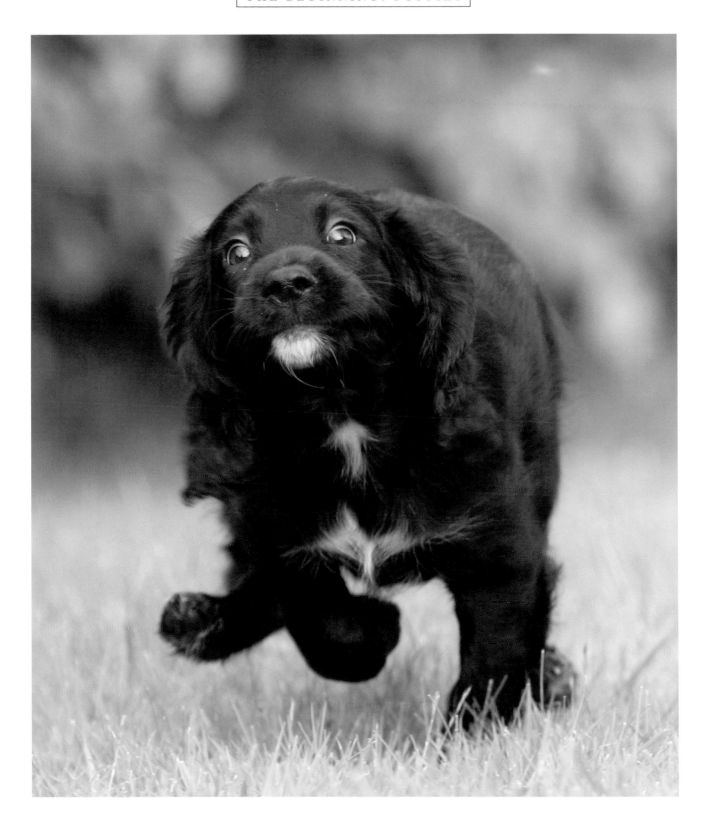

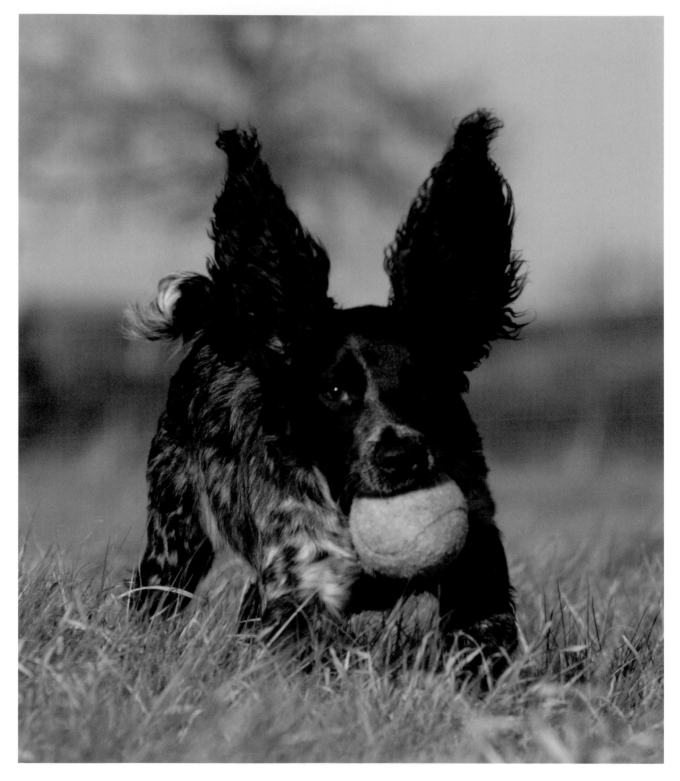

I am sure spaniels' ears are genetically programmed to reach their full size in a matter of weeks and the rest of their body catches up in due course.

I guess the saving grace for the owners of a new pup is that when they are charging around at full pelt their ears do act as 'air brakes' and this reduces their potential speed somewhat and for this we must be grateful. Anyone who has ever had the pleasure of stroking a spaniel's ear will tell you it is strangely therapeutic, furry on the outside and smooth on the inside, I know it has the effect of reducing my heart rate and it is a great stress buster.

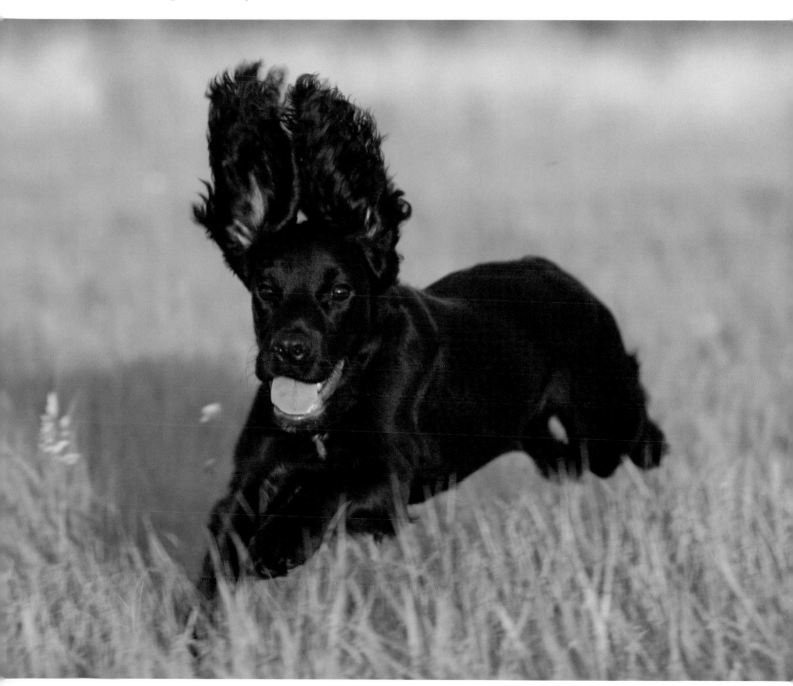

When charging around at full pelt a spaniel's ears must work as 'air brakes' and thus reduce their speed!

After all the frantic activity of the 'school playground' and the never ending investigation of new smells all young dogs need their sleep time and it is always a good time to get to work with the camera. I was having a particularly difficult session with a couple of litters of young Springer and Cocker pups which were full of vitality. The area in which I was photographing was quite large and they made full use of it. Add in to the equation that it was raining on and off and I really had earned my money. At long last they started to settle down for a siesta and I was able to get some intimate close ups. I love taking images of dogs as they get to the point where their eyes are still open but they don't seem to be looking at anything, they are in that total state of relaxation before drifting off to sleep. It is always difficult scooting around on my stomach or backside in an attempt to get into the right position without disturbing the dozing pup but on this occasion it was well worth the effort.

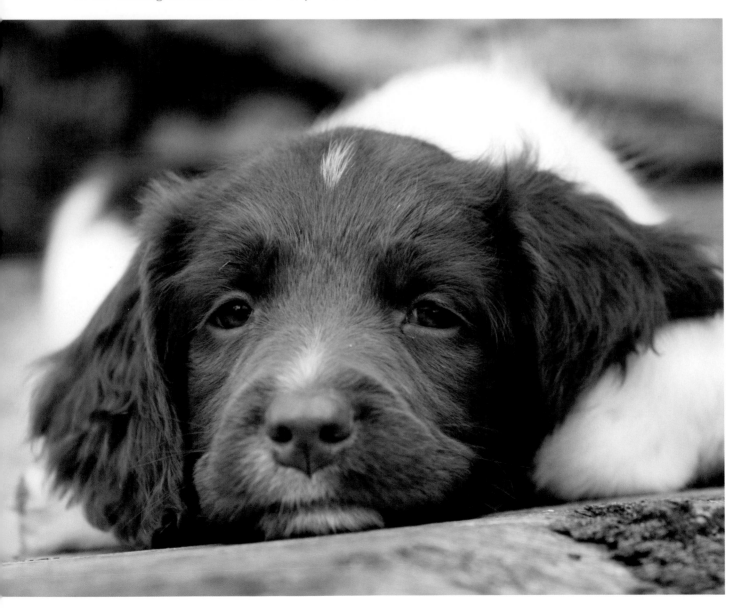

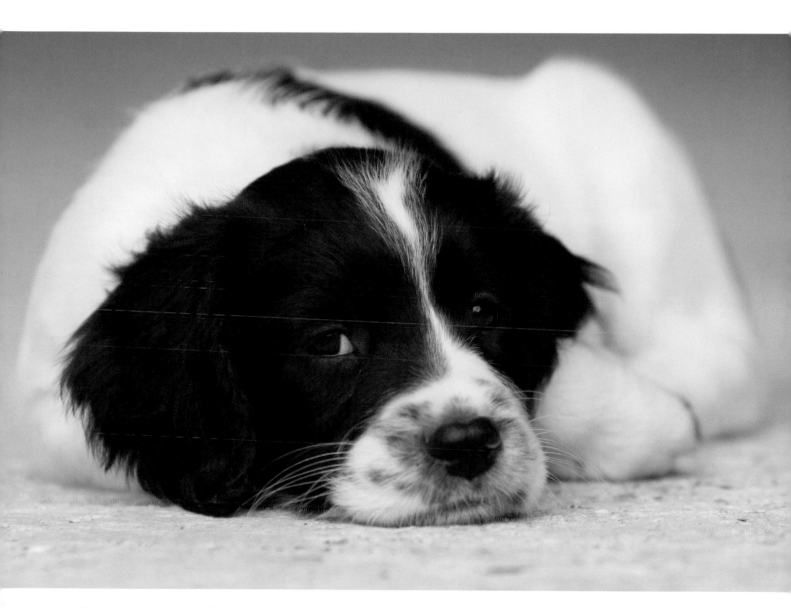

OPPOSITE, ABOVE AND OVERLEAF: After a frantic session with these pups I was grateful when they started to settle down for an afternoon siesta.

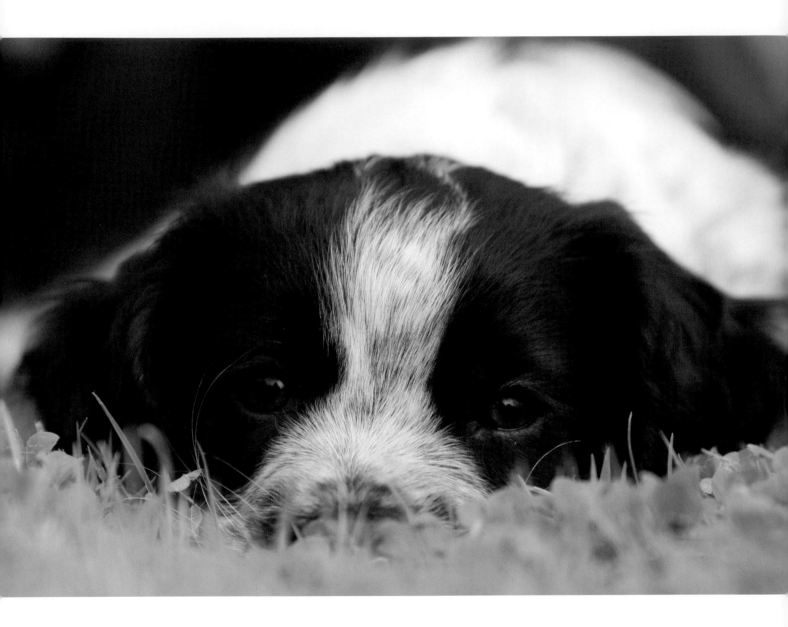

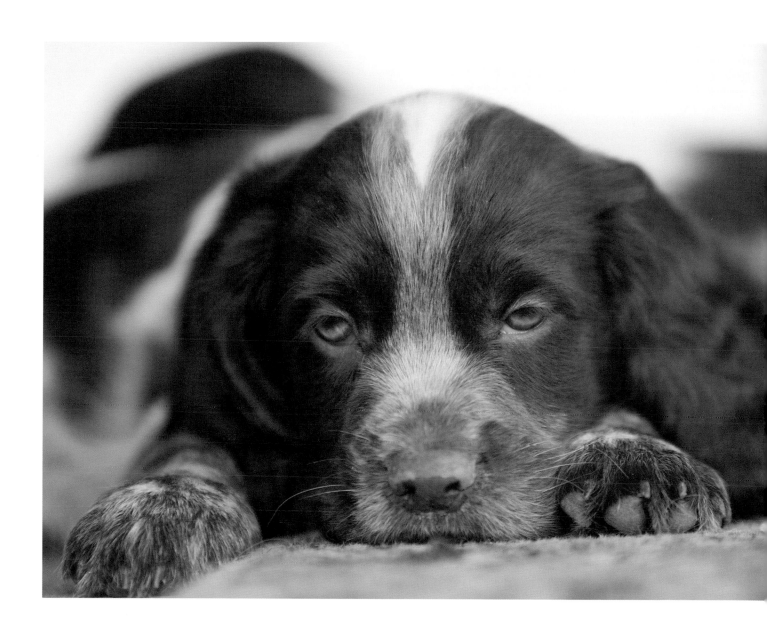

Every now and again I manage to get what I consider a special picture and there are a couple in my spaniel archives that make me smile everytime I see them. Getting cats and dogs in the same image is quite difficult and to get a puppy and kitten is really a tall order. A friend of mine had a litter of Springers and a litter of kittens born at the same time and I had heard that they shared the same beds and even ate out of the same bowls so I took a trip to see what I could get in the way of pictures. The pups had been outside but the kittens hadn't ventured outside so after taking some photos of the dogs we bought out the boldest kitten and placed her on the grass with one of the pups and the picture tells the rest of the story...it really was chocolate box stuff.

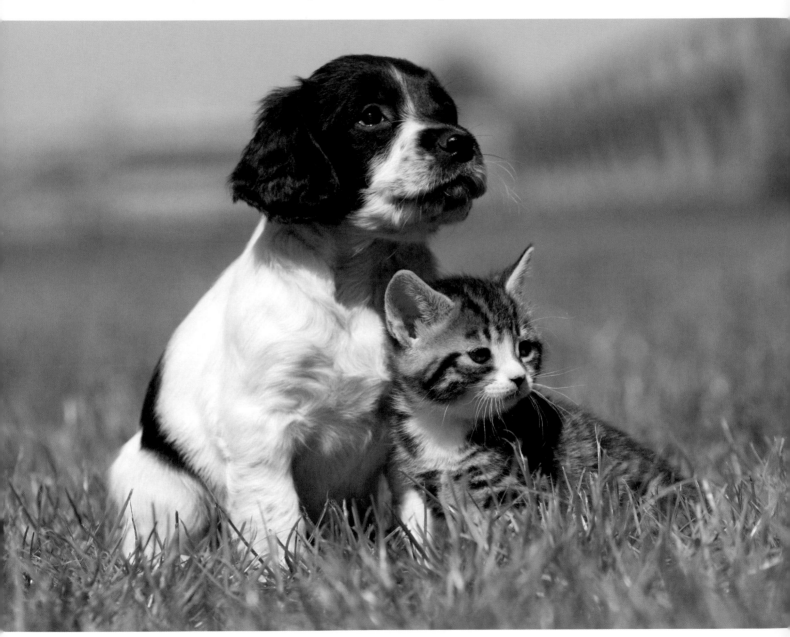

A classic chocolate box picture of a Springer pup and a kitten.

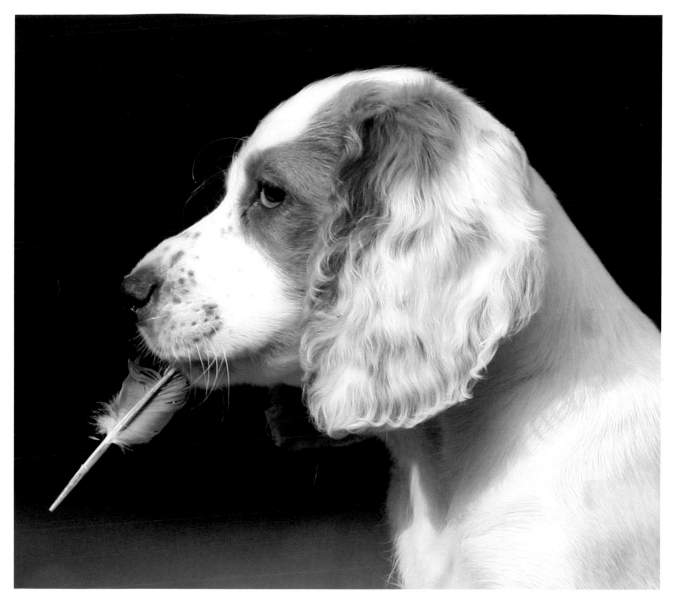

The dark background really helps the detail of the feather and the pup's head to stand out.

A few weeks later I was off to another friend who had a lemon and white Cocker pup and after a quite frantic session in the back garden the pup suddenly found a feather which she started playing with and then all of a sudden she sat up with the feather in her mouth Despite my age I still have good reflexes and I managed to get a couple of shots before she ran off again. Although there is a fair amount of skill involved in getting good images of dogs you also need a little bit of luck and this was one of those occasions when that bit of good fortune made all the difference. As the pup sat up she presented me with a profile of her head with the feather sticking out of her mouth, the real bonus was that the background was a dark hedgerow and this really made the shot stand out. You can see each individual part of the feather and her whiskers and eyebrows really show up, a couple of inches lower and the image would have lost most of its impact.

2 COME ON IN: THE WATER'S FINE

Have you ever sat around a dinner table and had one of those pretty inane conversations which goes something along the lines of 'if you were dropped into the middle of a desert what would be the one thing you would take with you?'

My answer would be simple…a spaniel. I know this may seem a strange answer but every spaniel I have ever known will find the smallest drop of water in the driest landscape, so it seems a pretty logical reply to me!

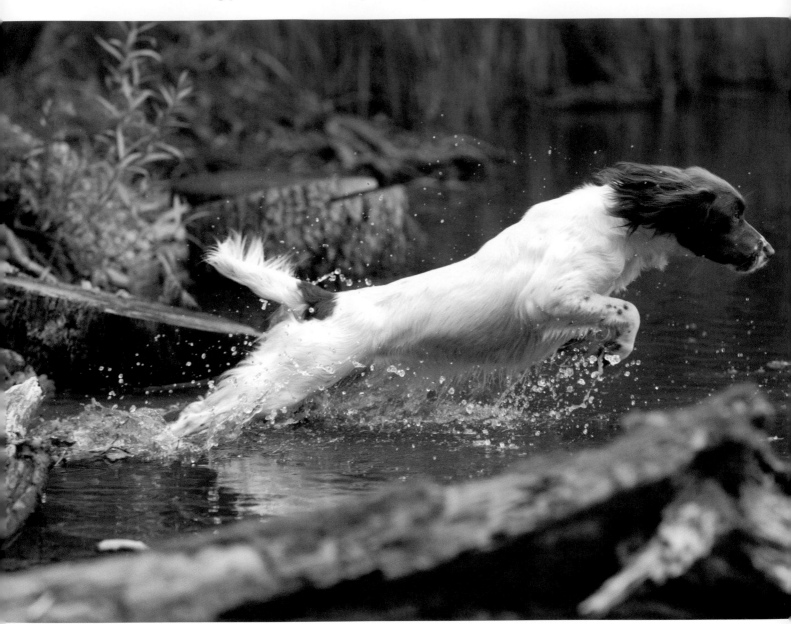

ABOVE AND OPPOSITE: If I had to take one thing to the desert with me it would be a spaniel…most spaniels that I know will find the smallest drop of water to play in.

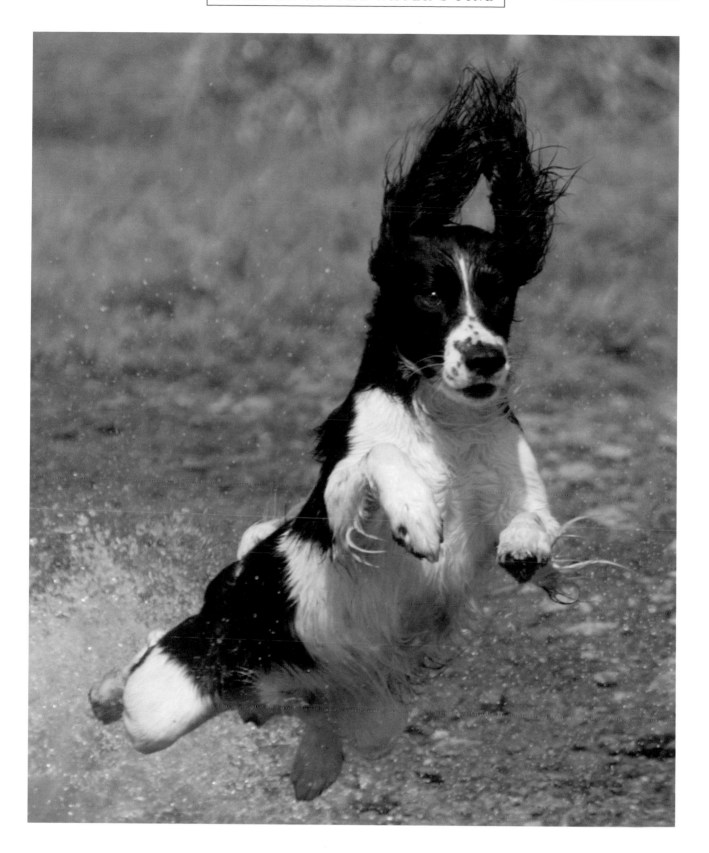

Generally speaking Springers and Cockers do not do as well as Labradors in water; they seem to suffer from the wet a bit more and their coats are not as waterproof. My Cocker Sweep has a coat like a sponge and she really does suffer if it is wet and cold, but you just try and keep her out of any stretch of water especially if there is something to retrieve.

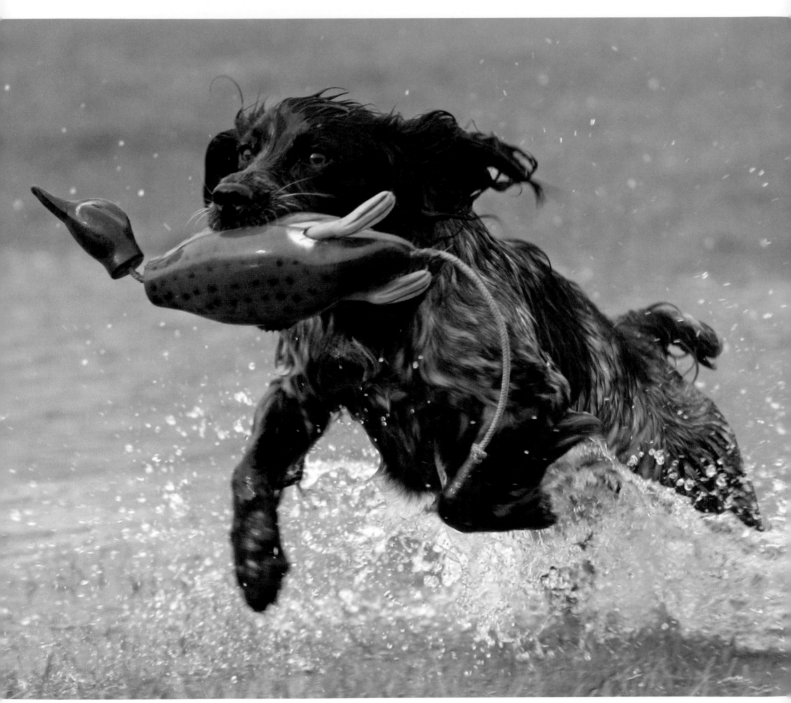

Sweep has a coat that is like a sponge but just try to keep her out of the water, especially if there is a retrieve.

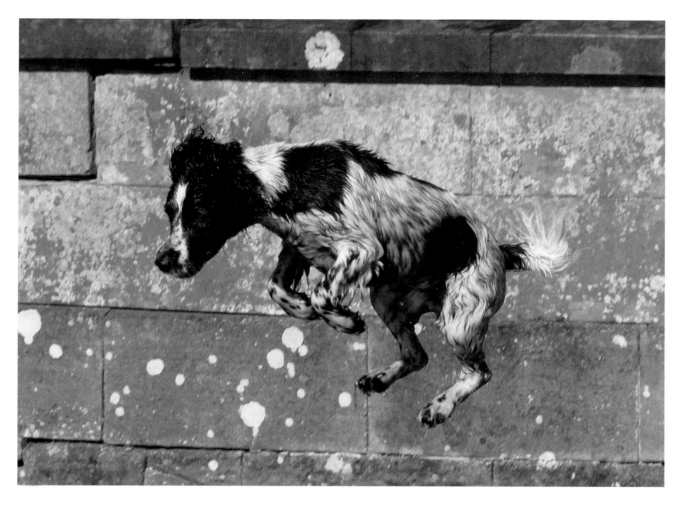

A depressed dog or an adrenaline junky? Fortunately this dog survived its jump from a bridge.

I get asked quite often whether I have a favourite image and to be truthful it does change but I always say that images of dogs in water are my favourites to take and I am always pushing the boundaries to get that extra special something. As I was trolling through my archives selecting images for this book I came across one that I had forgotten about as it was taken sometime ago.

I was covering a gundog working test and running through the ground was a lovely clear stream and most of the dogs were enjoying a bit of a splash about in the water. I was concentrating on photographing a couple of Labs playing when I saw a dog standing on top of the stone bridge and then without any warning it jumped, I quickly swung my camera round and managed to get one shot of the

dog before it hit the water. Now I don't know if the dog was suffering from depression and wanted to end it all or was just a bit of an adrenaline junky and was doing a kind of 'doggy base jump' fortunately a couple of seconds later it ran back up the bank and returned to its owner none the worse for its leap into the unknown.

Once I had come to my senses I checked the viewfinder on my camera and was relieved to see that I had caught the dog perfectly in mid air. This is one of those pictures that I always thought would make me some money, I hoped a pet insurance company would take it as an advert but as yet no-one has seen the potential and it has been sitting largely forgotten in my photo library…until now!

Spaniels are generally pretty bold when entering water and if I can get my positioning right I can normally get some pretty dramatic images.

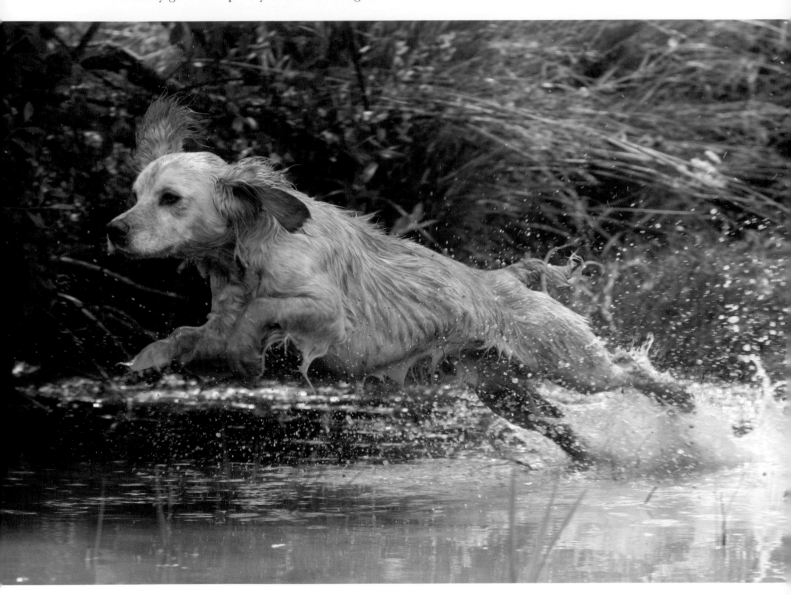

Spaniels are pretty bold when entering water as this lemon Cocker demonstrates.

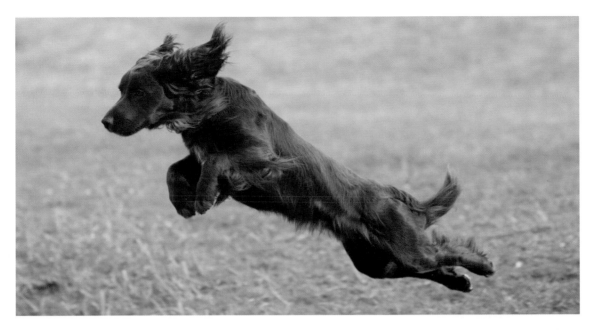

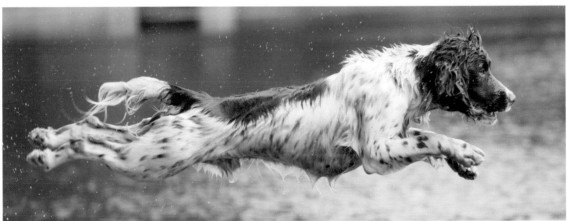

Over the years I have been looking at ways to get parallel with the dogs as they jump from the river bank as this is the best angle to show the dogs in full flight.

Over the past few years I have been looking at ways to get parallel with the dogs when they jump from a river bank as this is the best angle to show the dogs in full flight. I have never had the luxury of a boat so I have resorted to using neoprene chest waders and with a careful bit of pre-planning they have enabled me to really push the boundaries and get the kind of images that have the 'wow' factor, although being up to your neck in water with a spaniel hurtling towards you with a few thousands of pounds worth of camera gear in your hand is not

for the faint hearted. Over the years I have somehow managed to develop a sixth sense when photographing dogs and my timing has obviously got better to the point where my success rate is pretty good. When launching themselves off the bank most spaniels will really stretch out and it is this shape that I aim to capture. Quite often I will look to get into a position so I am sideways on to the dog as this really shows off their strength and flexibility and if my timing is out I just end up with an almighty splash and no dog!

Funnily enough deep water is not always photographically the best. Not far from where I live there is a shallow stream with sloping banks which is a great place to not only take pictures but also to introduce young dogs to the enjoyment of water. As well as photographing dogs I also enjoy working my own spaniels and after a training session with a friend we let the dogs cool off in the stream and as always I was looking for photo opportunities. As luck would have it I still had my waders in the car so I got kitted out, grabbed my camera and took up position in the middle of the stream.

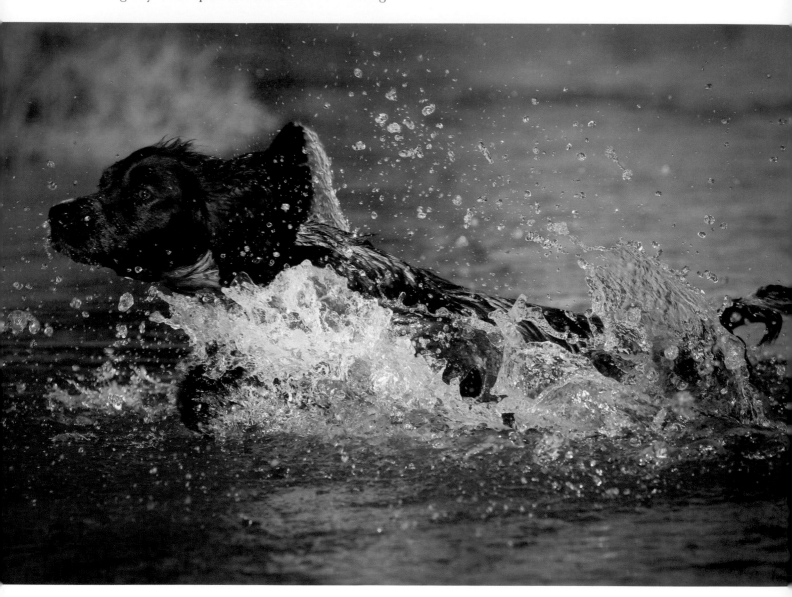

ABOVE AND OPPOSITE: Deep water is not always photographically the best; I prefer shallow water so the dogs can run through it.

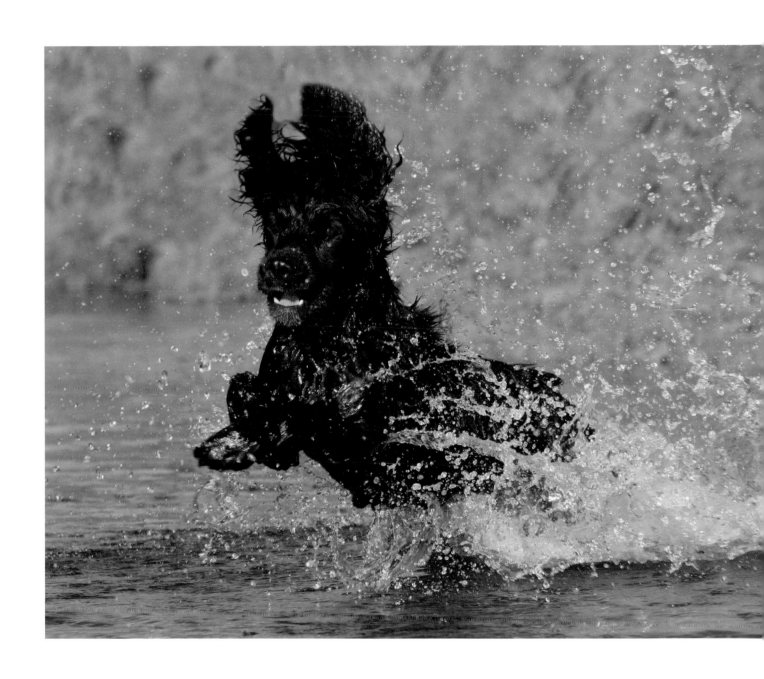

Anyone seeing me sitting in the flowing water would have been quite right in thinking that something very strange was going on, but dog photography is not glamorous but the results are well worth that bit of extra effort. One of my most famous images was taken in a very similar situation where once again I found myself sitting in what was a slightly deeper stretch of water but this time my waders had sprung a leak and it was getting quite uncomfortable! I had just finished a shoot for an outdoor clothing company and during the session we had used a really nice Springer spaniel and the owner wanted to give the dog a bit of a break so he let him have a run in the nearby river.

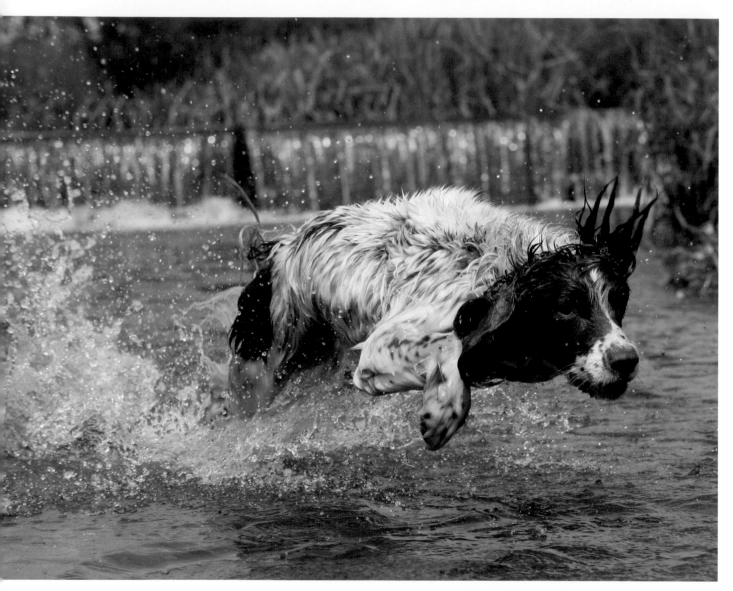

Anyone watching me take this picture would have thought me a little mad as I sat in the middle of a river. This image is one of my most famous and has been used all over the world.

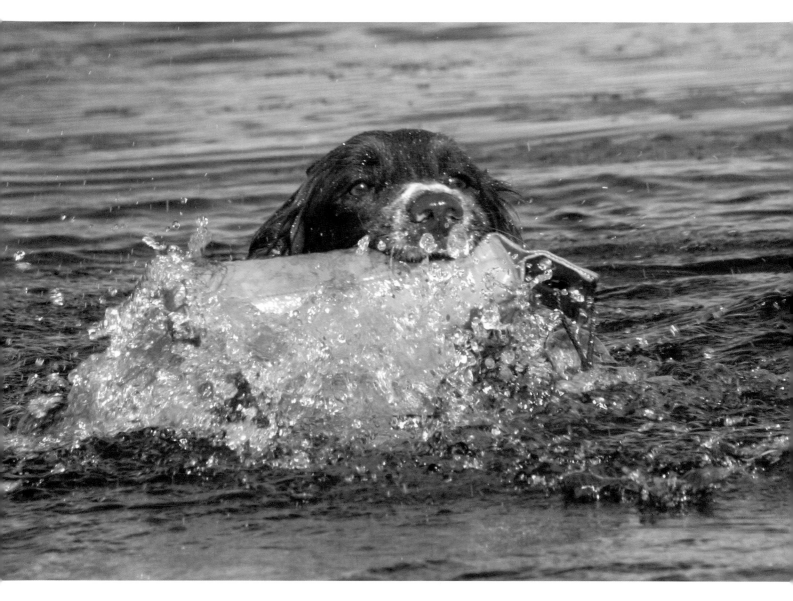

ABOVE AND OVERLEAF: Although mid air action is spectacular I do also like to get level with the dog's eye as it returns with a retrieve.

The dog really was bold in the water so I got the handler to throw a canvas retrieving dummy just to one side of me and then to send the dog. I used a wider angle lens so I had to wait until the dog was almost on top of me before I could start taking pictures and the results were quite spectacular, the camera needed a good dry off but it was well worth the effort. This picture has been used all over the world and although it was taken a few years ago it is still one of my favourites.

Although the mid air high action pictures are in my view the most spectacular I also like to get level with the dog's eye line when they are swimming back with their retrieves and this can be a bit more difficult especially when I am in the water and leaning forward to reduce the height of the camera angle.

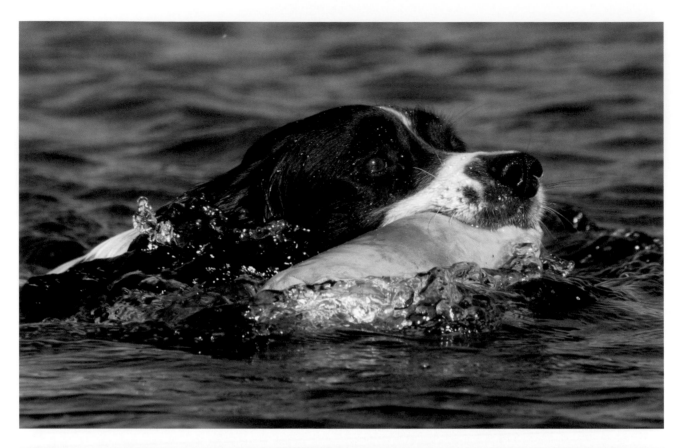

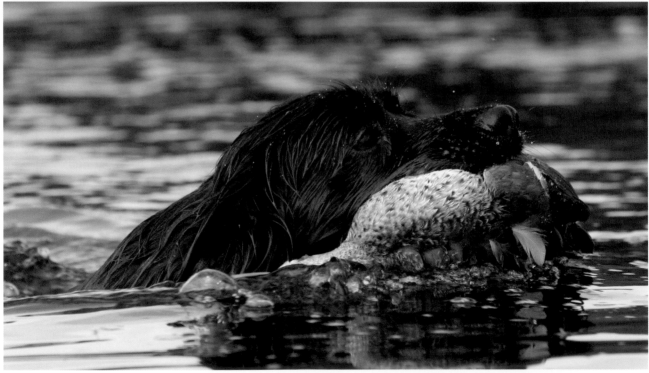

If I am lucky and the weather conditions are right I do sometimes manage to get some really good reflections of the dog's head,

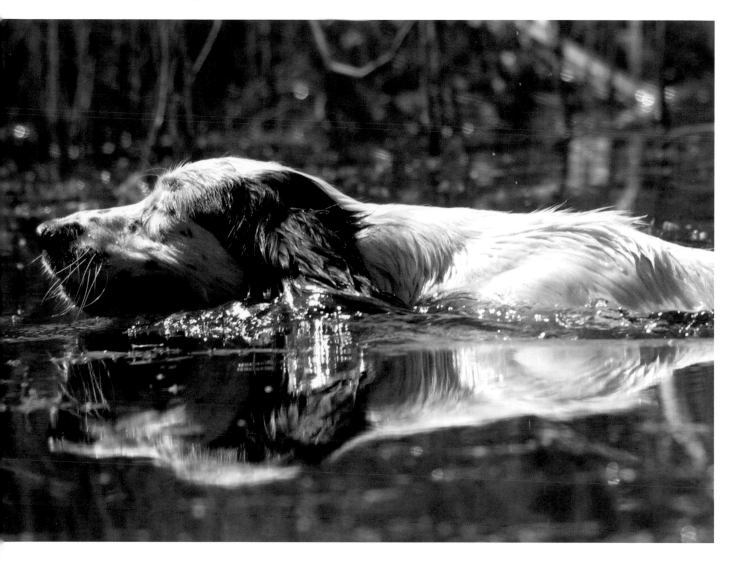

If I am lucky enough I can get some really good reflections.

I remember one shot I took of a black and white Springer where the reflection was almost three times the size of the dog's head, it is just a shame it wasn't retrieving something. It could have been a classic 'fisherman's tail'....I can just hear the owner showing the picture to his fellow Guns and saying...'do you know that pheasant was this big!'

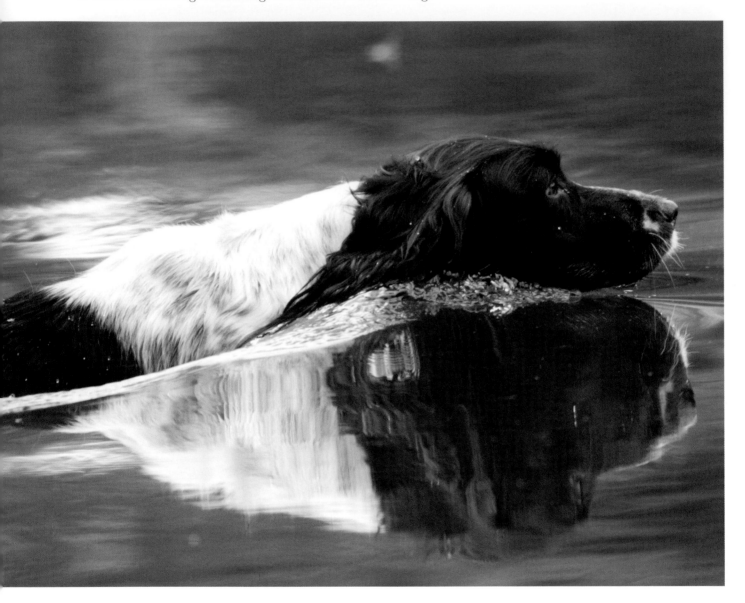

Sometimes the reflection is three times the size of the dog...if only it had been retrieving a duck or pheasant.

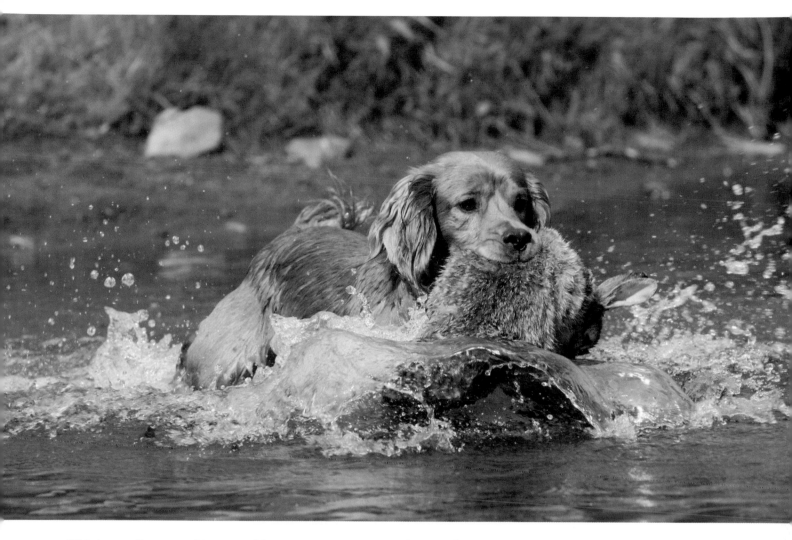

This is a really unusual image as I have never seen a picture of a spaniel retrieving a rabbit through water. It was one of a sequence taken during a rabbit shooting trip high on the North Yorkshire moors.

Every year I am lucky enough to spend a few days shooting rabbits high on the North Yorkshire moors with a group of Cocker spaniels and as we returned back to the vehicles after a very enjoyable few hours I saw the perfect opportunity to get some unusual images. A rabbit had just been shot on the far side of a small beck and one of the dogs had been sent to retrieve it. As the dog came back through the stream the sun suddenly came out and the whole scene lit up before my eyes. I took a series of shots as the dog splashed back and when I looked at my LCD screen on the camera I was really pleased with the results.

I had never seen any images of a dog retrieving a rabbit through water so that was a first for me but more importantly than that the sun had highlighted the water and really lifted the whole image. It was hard to pick an individual image out of the sequence but my favourite picture shows the dog in mid stream with a bow wave in front of the rabbit, the amazing thing to me is that the water was so clear you can see the body of the rabbit through the water. I will take some credit for seeing the image in the first place but nature took care of the rest!

As well as taking pictures of spaniels swimming, jumping or running in water I also keep a very close eye out for 'the exit' shots. As anyone who has ever owned a spaniel will tell you their tails never stop wagging and as they leave the water quite often you get a 'flick' of water droplets from the end of the tail, and then there is the 'shake'. Watching a wet Cocker or Springer spaniel shake water from its sodden coat really is quite amusing especially as the ears seem to take on a life of their own in fact I quite often wonder why they don't lift off the ground like some canine helicopter!

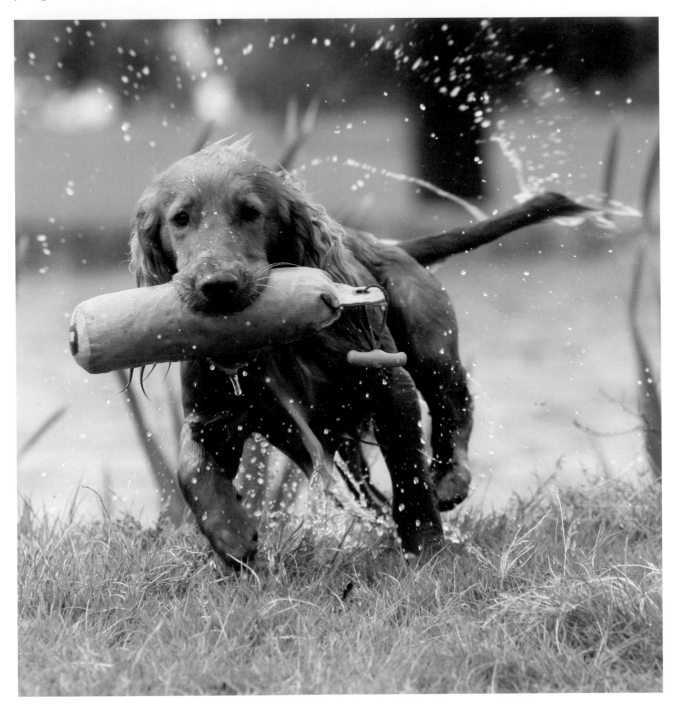

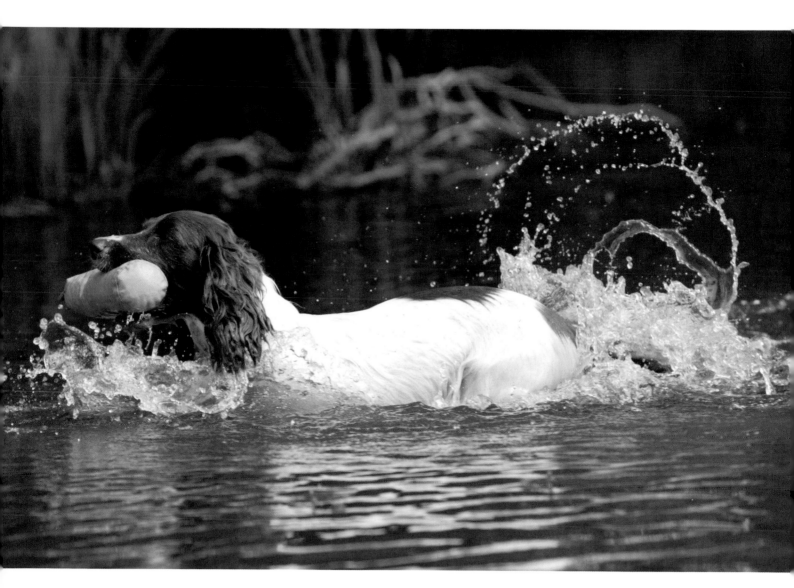

OPPOSITE AND ABOVE: I always keep a watch out for the 'exit shots' and will hopefully get plenty of tail flick as the dogs reach dry land.

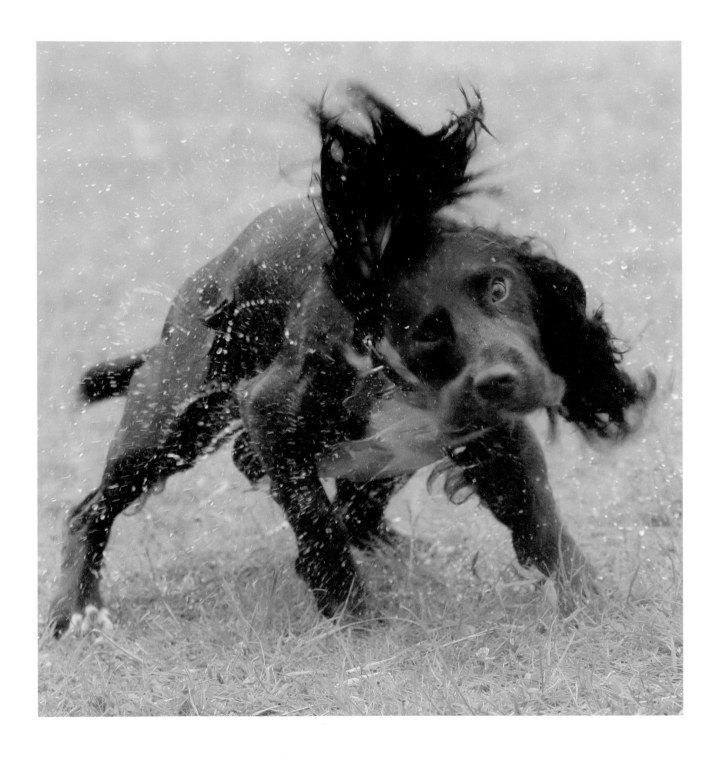

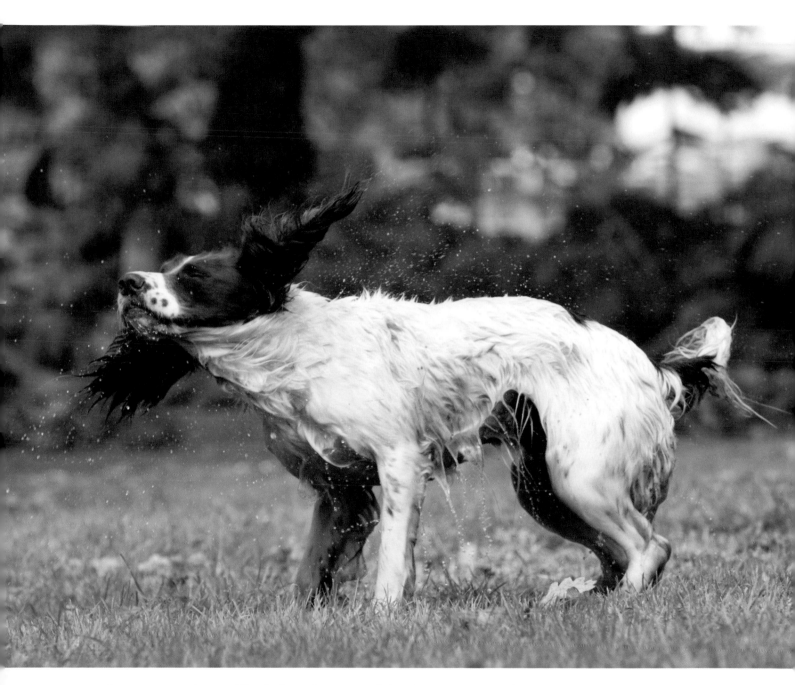

OPPOSITE AND ABOVE: The shake is always a good shot, how these dogs don't actually take off is beyond me!

3 SPANIELS AND RABBITS: THE PERFECT COMBINATION?

Way back in the mists of spaniel history both the Cocker and the Springer spaniel could both be born in the same litter and the division in the two lines came down to how much the adult dog weighed. If my memory serves me correctly a Cocker was a dog under fifteen pounds in weight and a Springer was a dog over fifteen pounds and over the years as the two breeds were selectively line bred they also started to become 'specialist' in hunting for certain quarry.

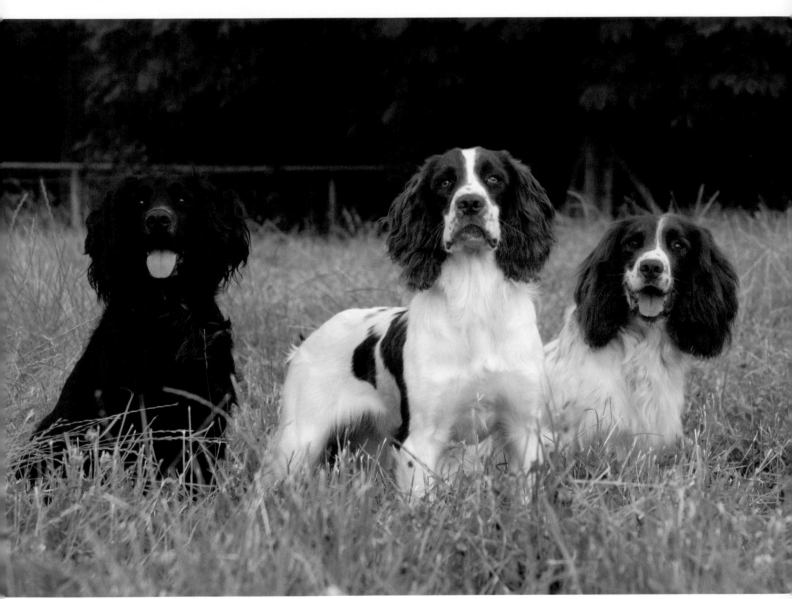

Originally both Cockers and Springer spaniels could be born in the same litter and it was their weight that dictated the outcome of their breed.

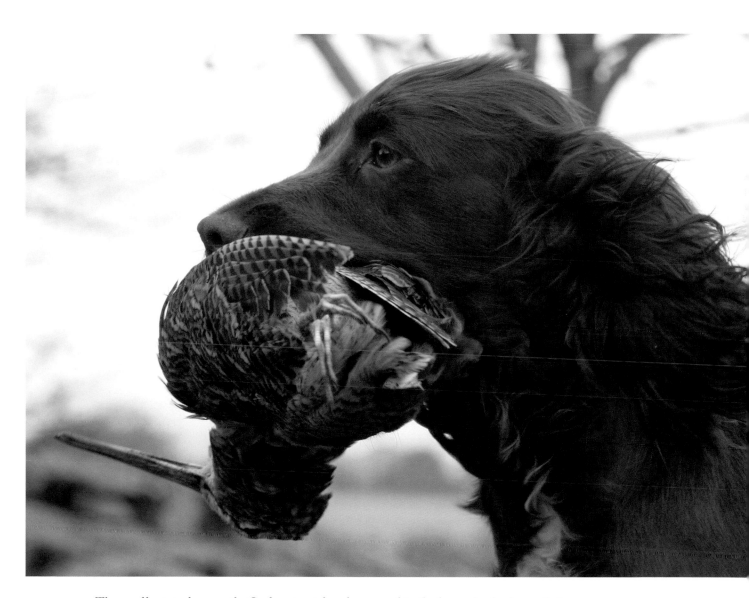

The smaller type became the Cocker spaniel and was used to flush woodcock...hence their name.

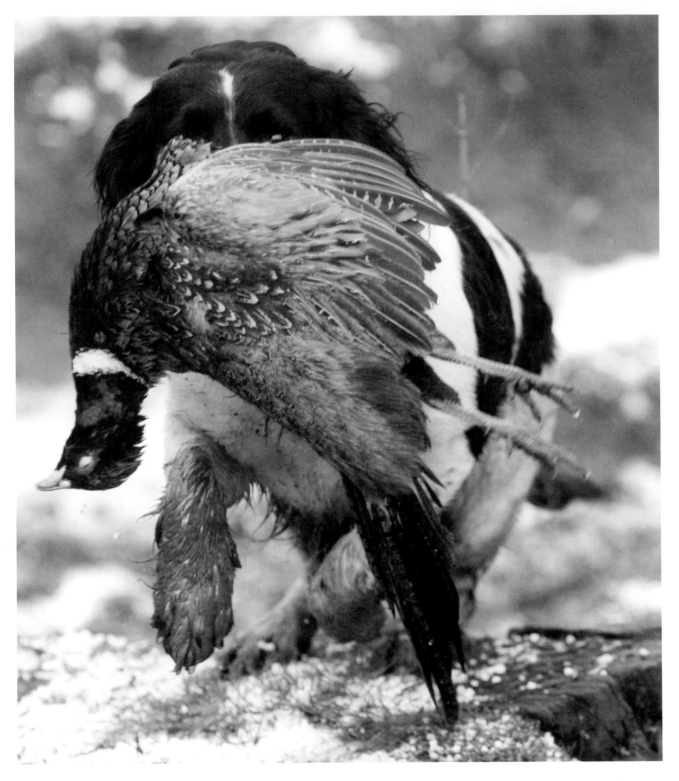

Its larger cousin was a more versatile dog and was used to flush or 'spring' game birds and ground game, hence the name Springer spaniel.

During the late 1940s and early 1950s the rabbit population was at its height and some spaniel historians maintain that the two breeds of spaniel were also at their peak. The country was literally overrun with rabbits and both the Cocker and Springer became experts at hunting the ever growing population and then myxomatosis hit and over ninety-five per cent of rabbits died and the spaniels had to shift their skills to feathered game.

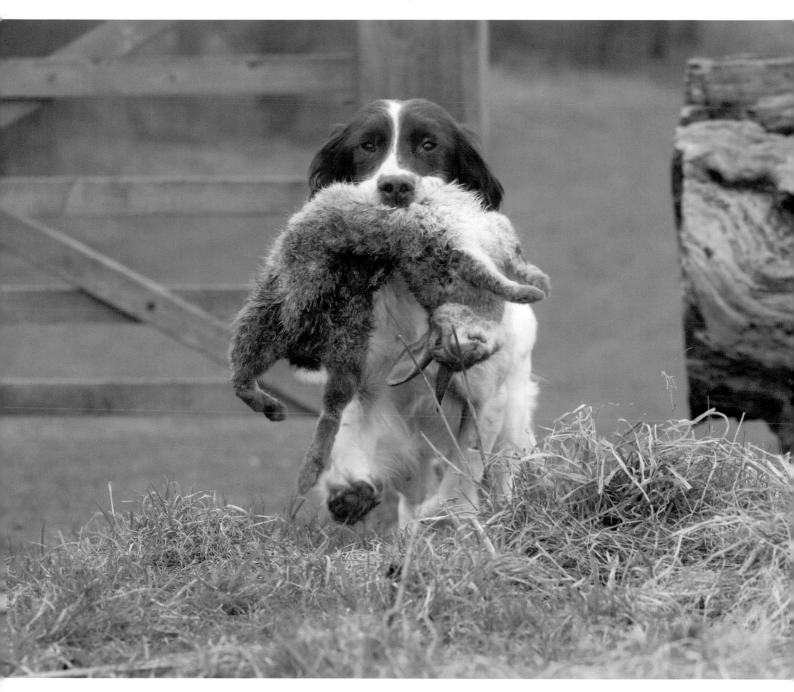

As the rabbit population grew in the late 1940s and early '50s the versatile spaniels became expert at hunting conies.

Fortunately (for some) the past few years has seen the rabbit population boom and it is said that in certain places in the UK the population is now greater than in pre-myxi years. I live in the south of England and although we do have a reasonable number of rabbits about they tend to spend most of the daylight hours underground…however travel a few hours up the motorway and it is a different story. I am fortunate that my job takes me to some wonderful parts of the country and my favourite has to be the North Yorkshire moors.

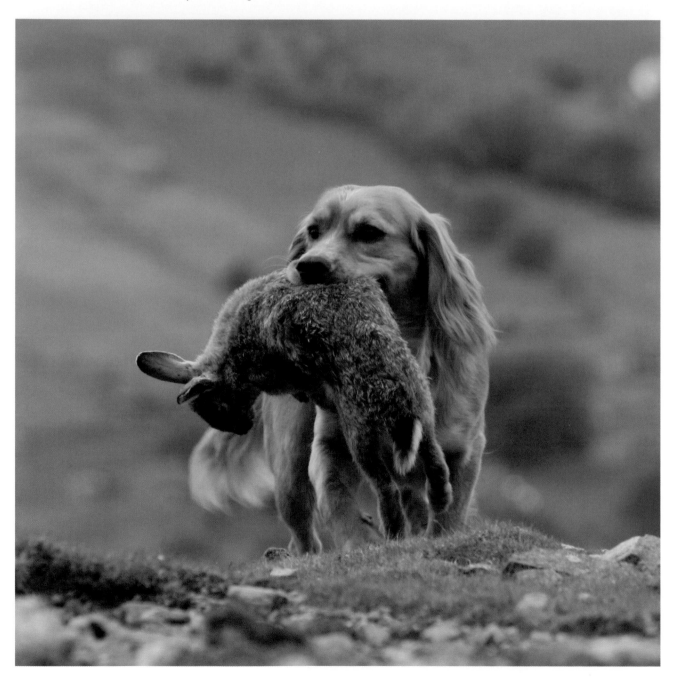

The North Yorkshire moors have some wonderful scenery and an abundance of rabbits.

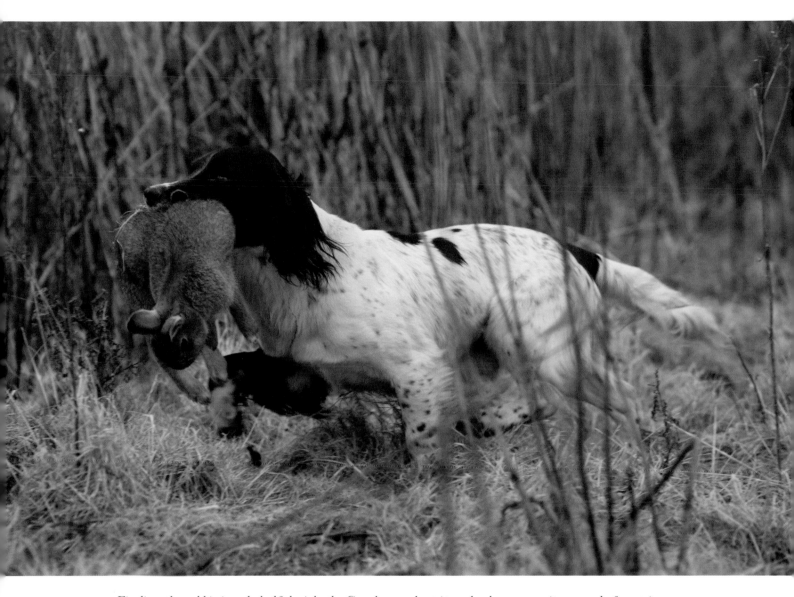

Finding the rabbit is only half the job, the Gun has to shoot it so the dog can get its reward of a retrieve.

As well as having some spectacular scenery it just so happens the county also has an abundance of bunnies that seem to spend most of their time tucked under the white grass that covers many of the fields. I do enjoy a day out with my gun and my dogs, but given the choice of standing at a peg at a prestigious high bird shoot or wandering through a stone-walled, windswept field with a spaniel hunting rabbits ...well for me there is no choice. There is something mesmerising about watching a hard hunting spaniel quarter its ground and then suddenly punch into a patch of white grass and a rabbit exploding out of the other side. To me it is the ultimate form of gundog work; in fact it is the perfect example of Man and Dog working as a team. Of course finding the rabbits is just one aspect of the job, to complete the task the handler has to shoot the rabbit so the dog can get its reward of a retrieve.

If you have never experienced the thrill of trying to shoot a rabbit that is running downhill at a vast rate of knots whist jinking in between lumps of granite boulders then you must put it at the top of your list of 'Things to Do before I Die!'

Not long after I had been commissioned to write this book I travelled up the motorway to visit a good friend who has access to some of the best rabbiting ground in the country and he also has some pretty useful Cocker spaniels that excel at this kind of hunting. I wanted to get some library pictures of the dogs but I also wanted to try and get some different angles so that I could include as much of the landscape as well as the dogs – most of my photography concentrates on the dogs and generally very little of the surrounding landscape.

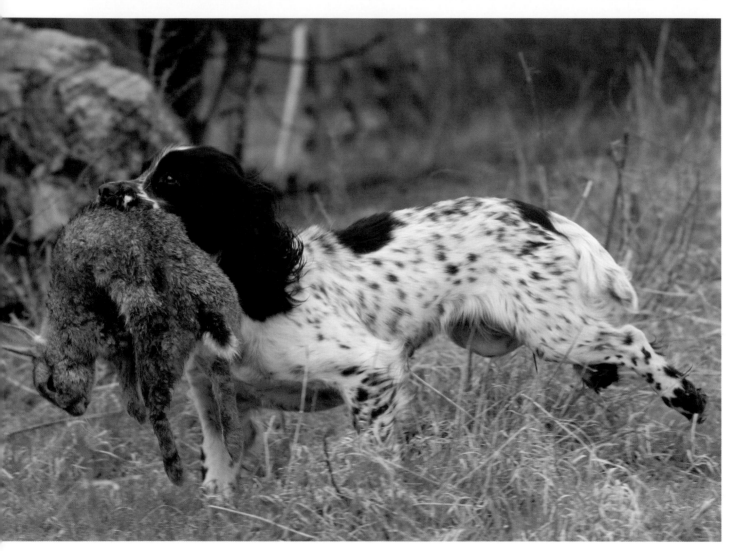

Most of my photography concentrates on the dog at work rather than the surrounding landscape.

This is mainly because my clients like to see close up images of their dogs at work so my style is often commercially rather that artistically driven, however on this day it would be the other way around. The day was a typical North Yorkshire summer's day, overcast and windy but at least it was dry, and as with all good plans things didn't quite work out as hoped.

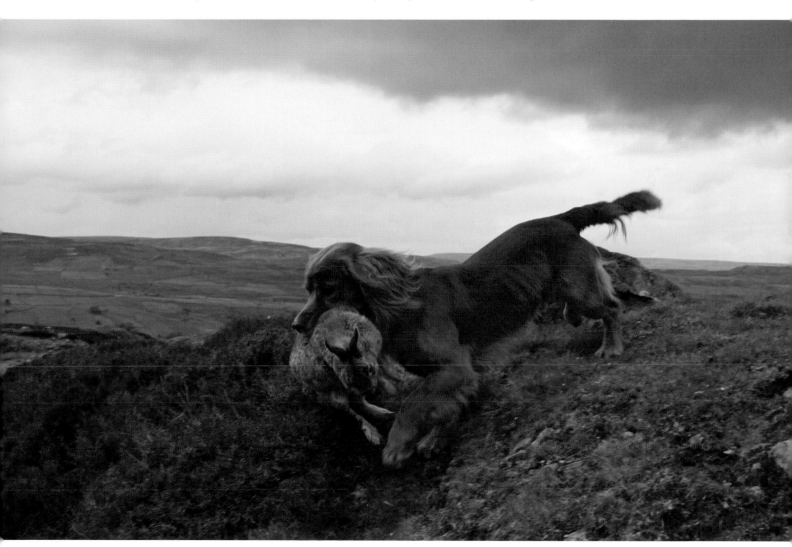

A typical North Yorkshire summer's day...overcast and windy but in one way this helped to create a more dramatic image.

SPANIELS

The dogs hunted and hunted and hunted and for some reason the rabbit population had decided not to be very helpful! I had been to this part of the moor before and it is normally alive with bunnies but today the dogs would really have to work hard. As the day went on we started to find some quarry and I started to get my images. I used a wide angle lens to make sure I included the landscape but as a consequence I had try and get as close to the dogs as I could to avoid them looking miniscule in the frame.

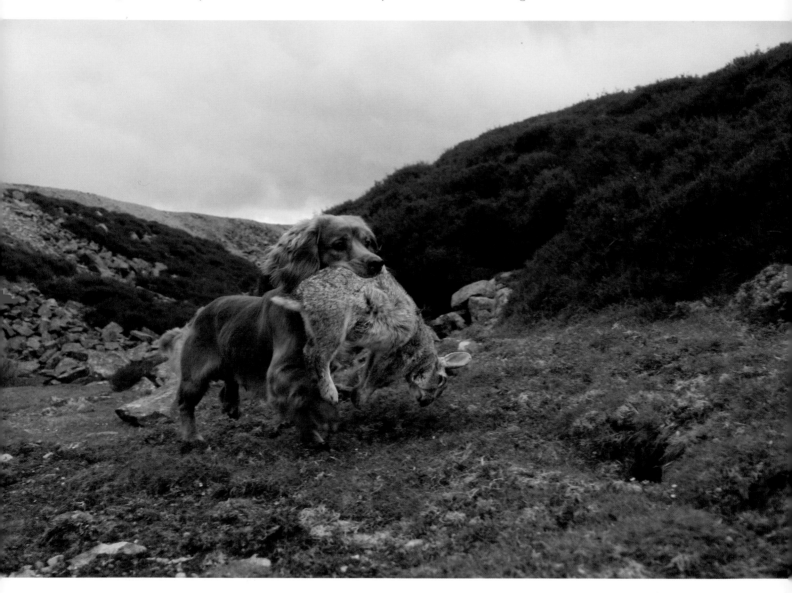

By using a wide angle lens I was able to capture the landscape as well as the dogs making their retrieves.

I also wanted to be absolutely level with the dogs and this meant climbing into becks and streams and down rocky banks…being a dog photographer is not at the glamorous end of the business, in fact at times it is downright uncomfortable! The one aspect I love about this high ground landscape is that if you get your positioning right you can produce an image with a backdrop that is so blurred it looks almost like a water colour painting.

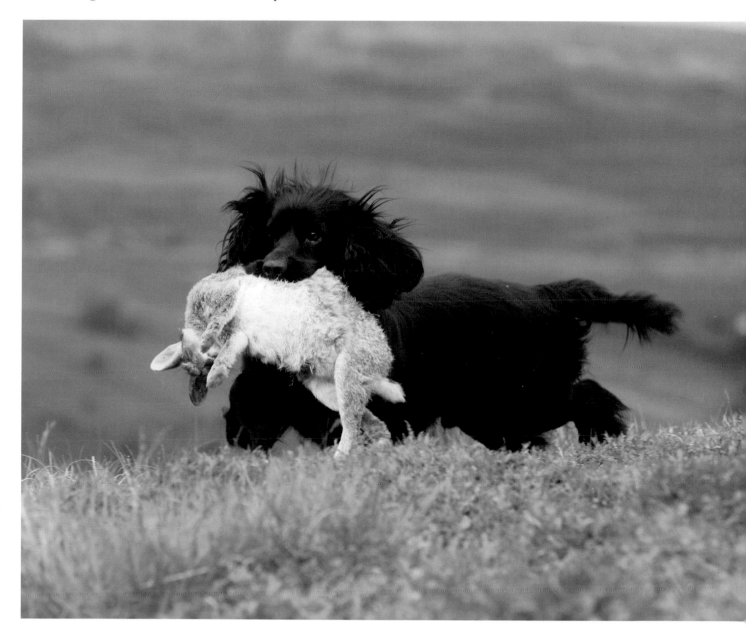

I wanted to get absolutely level with the dogs and this meant scrabbling down rocky banks…being a dog photographer isn't glamorous!

I had my own Cocker spaniel, Sweep, with me and I gave her a run and not long into her hunting pattern, which incidentally *isn't* the usual frantic spaniel style, she flushed a rabbit and it was shot and as she came back with it I realised what heart these little dogs have. She is no more than ten inches tall and yet she can retrieve a rabbit that is not much smaller than herself and probably weighs around the same. I have also seen her come back with a very lively cock pheasant which was battering her head with his wings all the way back!

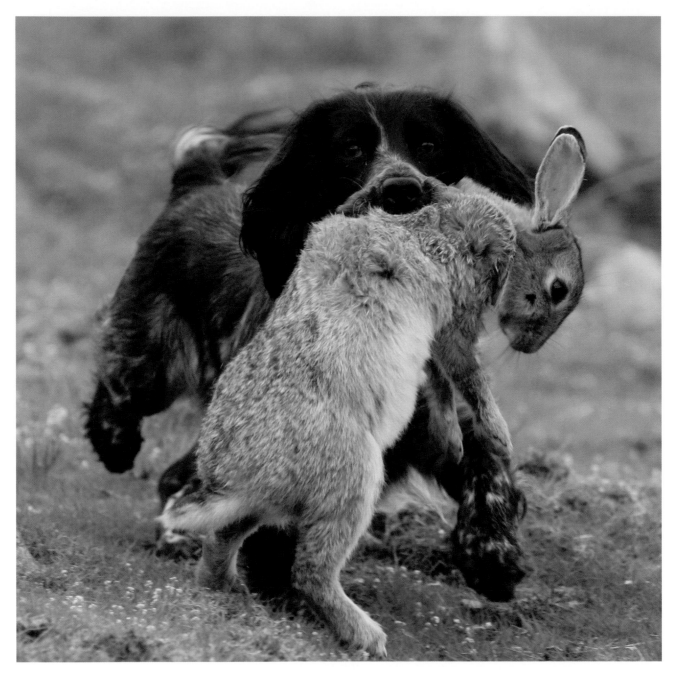

Sweep is only ten inches high but she can still retrieve a rabbit that is nearly as big as her.

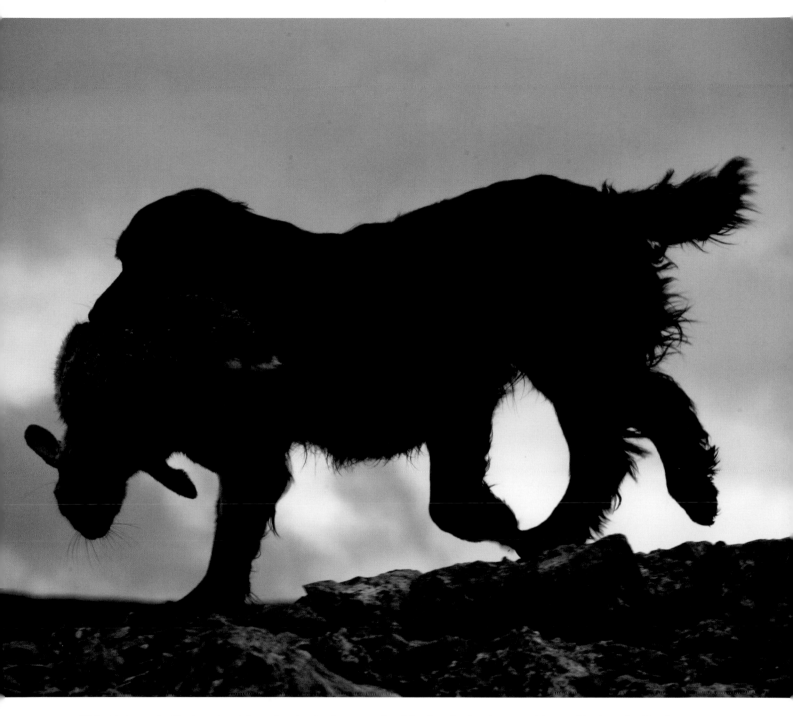

This picture of a Cocker spaniel coming back along a rocky ridge just had to be turned into a black and white image.

I don't often take black and white pictures but just as we were finishing for the day one of the dogs came back with a rabbit along a rocky ridge and I took a couple of quick frames, and when I got back to the office and downloaded all of the images this one just cried out to be converted from colour to black and white and turned into a silhouette.

Just before I leave the subject of spaniels and furry creatures it never fails to amaze me what these dogs will retrieve: twice this year I witnessed a Cocker and a Springer retrieve fully grown hares from a good distance and when you consider a hare is a challenging retrieve for a Labrador, let alone a spaniel this was quite an achievement.

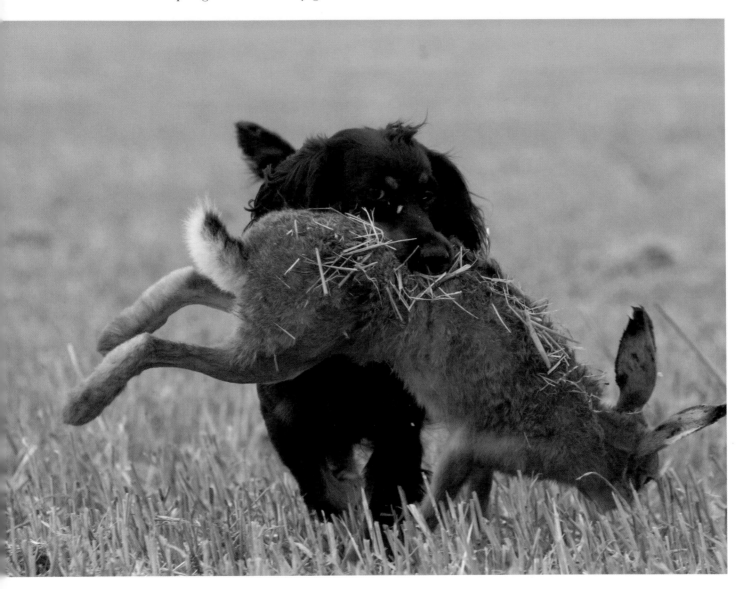

ABOVE AND OPPOSITE: A hare is a large retrieve for a Labrador let alone a Cocker or Springer spaniel.

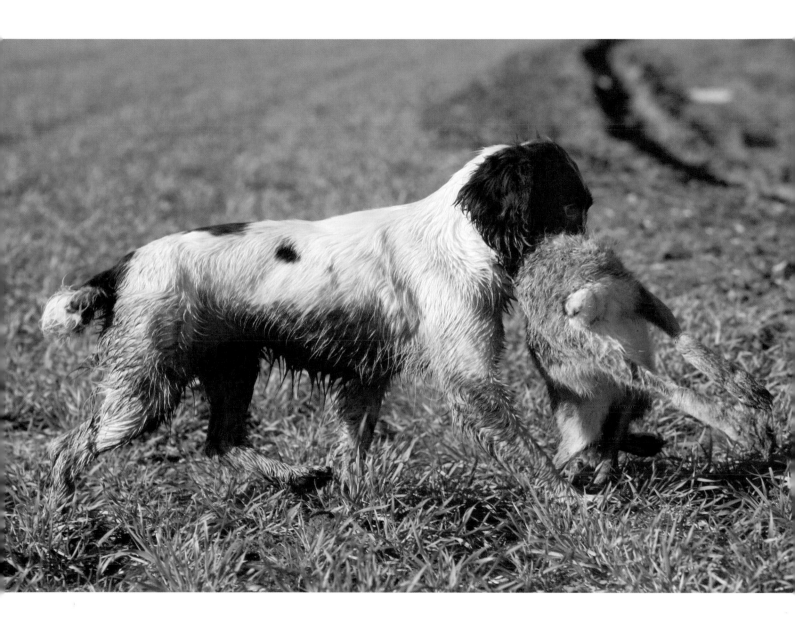

4 SPANIELS IN THE FIELD

In the shooting field the working Springer and Cocker spaniel are the 'jack of all trades'. A well trained spaniel should hunt within gun shot (anyone with a hard hunting dog will tell you that this is easier said than done!) stop to flush and shot and then retrieve tenderly to hand…a tall order for not only the dog but also the trainer.

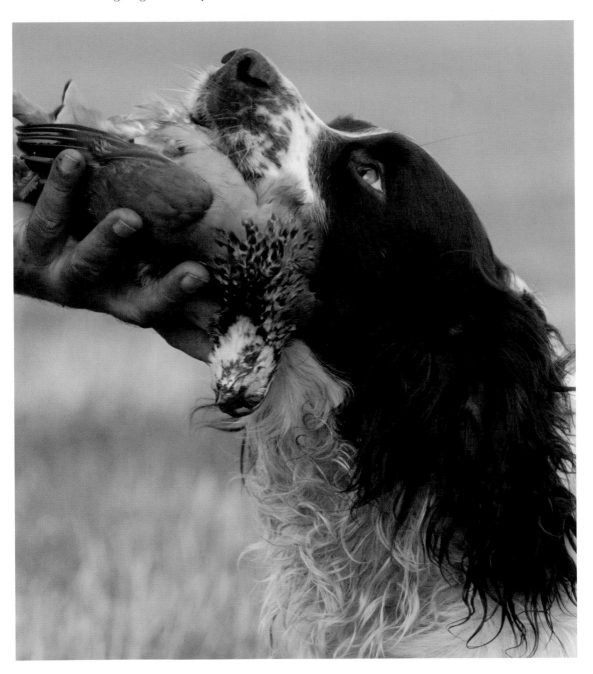

As well as hunting, a spaniel should be able to retrieve to hand.

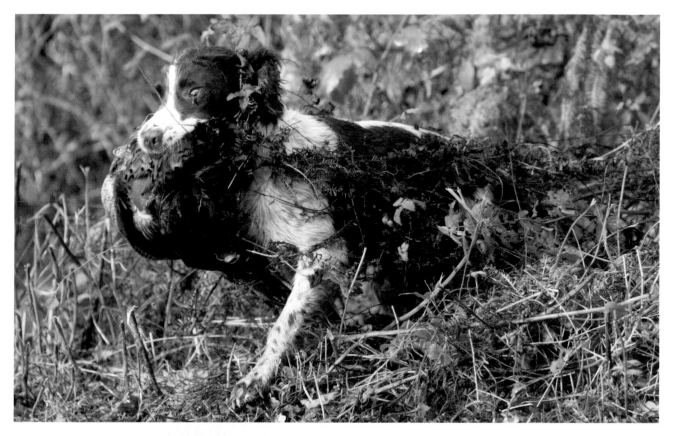

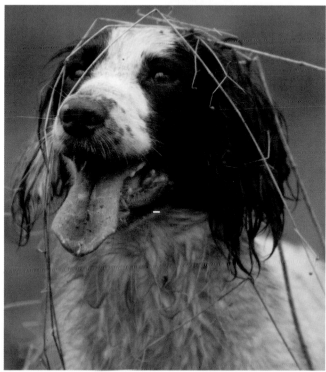

ABOVE AND LEFT: Spaniels are renowned for their ability to literally tear heavy cover apart in their quest to find game and as a consequence can often look the worse for wear at the end of a day's work.

During the 2008 Spaniel Championships I was to witness some very fast and indeed brave dogs working very difficult cover.

The event is the equivalent of the FA Cup Final for spaniels; the qualifying dogs have all competed throughout the year at various field trials and the best of the best compete in a gruelling three day test of stamina, style and steadiness. The ground was typical spaniel cover consisting of laid stick piles covered in brambles, it was tough going for the dogs and they had to work hard to find their quarry and the speed and ferocity with which they dealt with the cover was truly awesome.

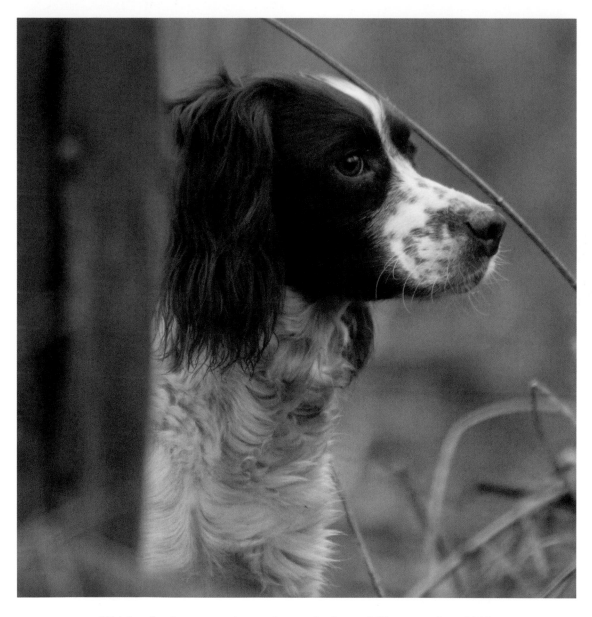

Waiting for the command to go during the Spaniel Championships 2008.

OPPOSITE: The going during the 2008 Spaniel Championships was particularly difficult, not only for the dogs but I didn't find it easy to get shots in the heavy cover.

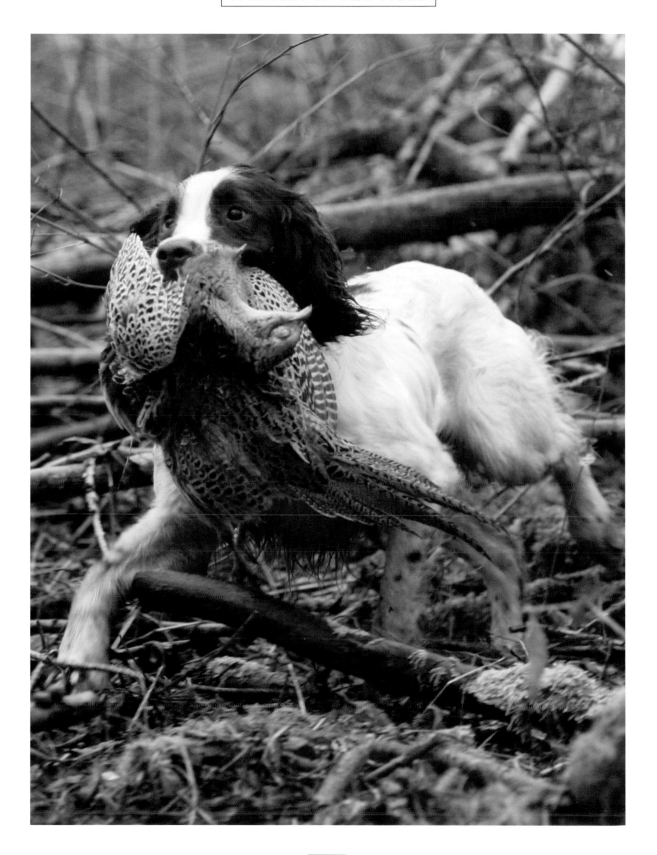

Photographing dogs in such difficult cover is challenging to say the least and I had to pull on my knowledge of the dogs and the way that they work as much as I do my photographic skills.

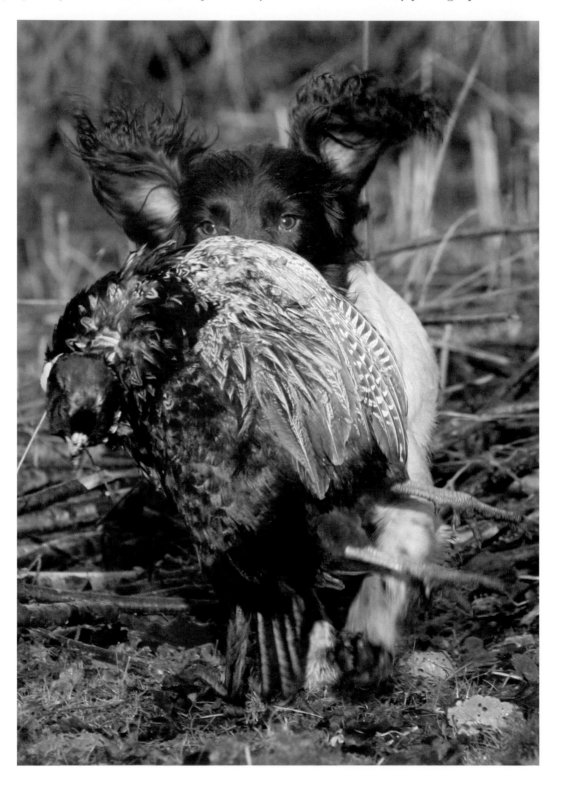

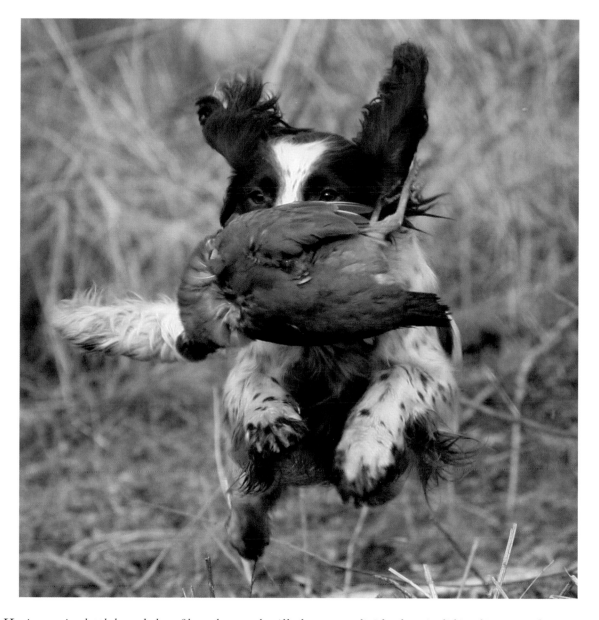

Having an in-depth knowledge of how dogs work will always pay dividends as it did in this particular image.

Catching the dogs coming back with a retrieve was particularly difficult as quite often there was a lot of grass or bramble in the way, but like all animals the dogs would always choose a natural track to follow and on one particular occasion my observations paid dividends. The only partridge to be shot during the whole trial fell into a rhododendron bush and the dog was sent for it. As I watched it go I noticed a small track which I was sure the returning dog would follow and as luck would have it that is exactly what happened. I had also seen that half way along the track was a small stick pile and I gambled on the dog having to jump over the sticks so I pre-focused the camera just in front of the sticks and waited.

OPPOSITE: Difficult going during the 2008 Spaniel Championships for both dogs and photographer.

Out of the corner of my eye I saw the dog running back down the track and sure enough as she reached the stick pile she took off and I hit the shutter button. The resulting shot was perfect, the dog's eyes were as sharp as a tack, I caught the dog in mid-air, the bird's wings are closed and although it may seem insignificant the dog's tail has come out to one side which, to my eye balances the picture perfectly. A bit of luck…well yes but also a case of knowing your subject matter intimately and the ability to see a picture long before it happens.

A grouse moor at the height of summer isn't the natural environment that you would expect to find a 'clan' of Cockers plying their trade but I had heard of a team that as well as being top quality field trial dogs were also pretty good at sweeping up after the frantic action of a grouse drive so once again I headed up north with my camera and I was impressed with what I saw.

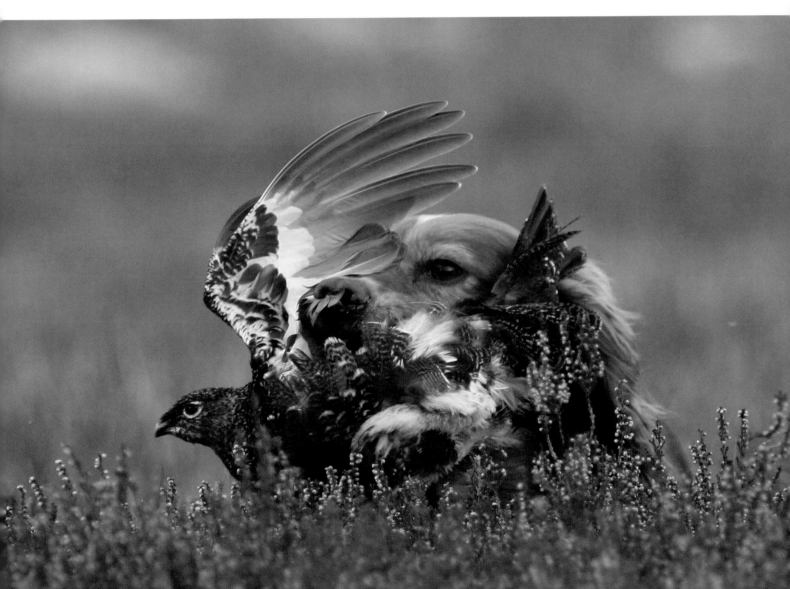

A grouse moor in the height of summer has to be one of the most inhospitable places for a dog to work.

During a grouse drive it is imperative that the dogs sit absolutely still.

The grouse moors in August have to be some of the most inhospitable places for any dog to work let alone one as small as a Cocker spaniel, not only is the heather very difficult to negotiate but the amount of pollen that rises from the flower heads has to be seen to be believed. If you consider that the dog's extremely sensitive nose is just above the level of the small bell-like flowers and that in most cases the grouse will have fallen deep into the heather and it is a wonder that they can scent anything.

If you add in to the equation the very hot weather and you could not be further from the traditional hunting grounds of the Cocker spaniel, but these dogs really did know their stuff and I was particularly impressed by how they sat so still during the drives which could take anything up to forty-five minutes and then went out like a starburst as they started hunting for the fallen birds.

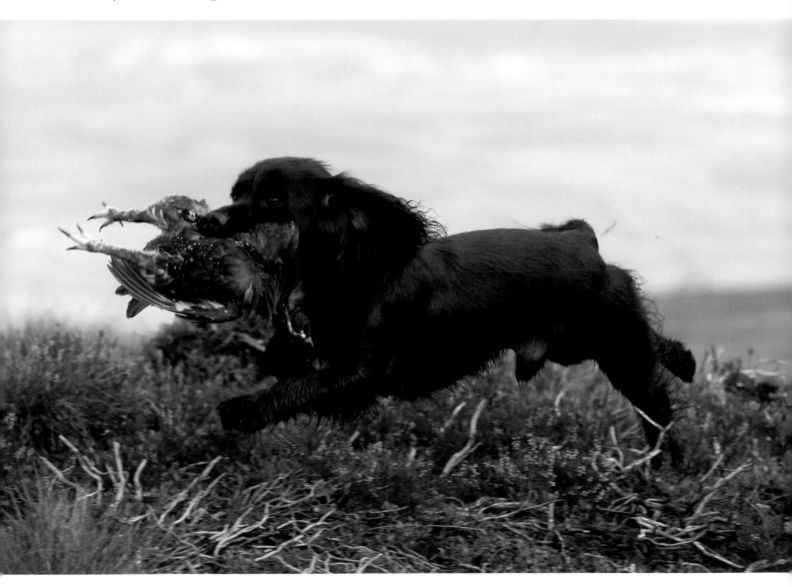

ABOVE AND OPPOSITE: The grouse were not easy to find in the deep heather but these Cocker spaniels really knew their work.

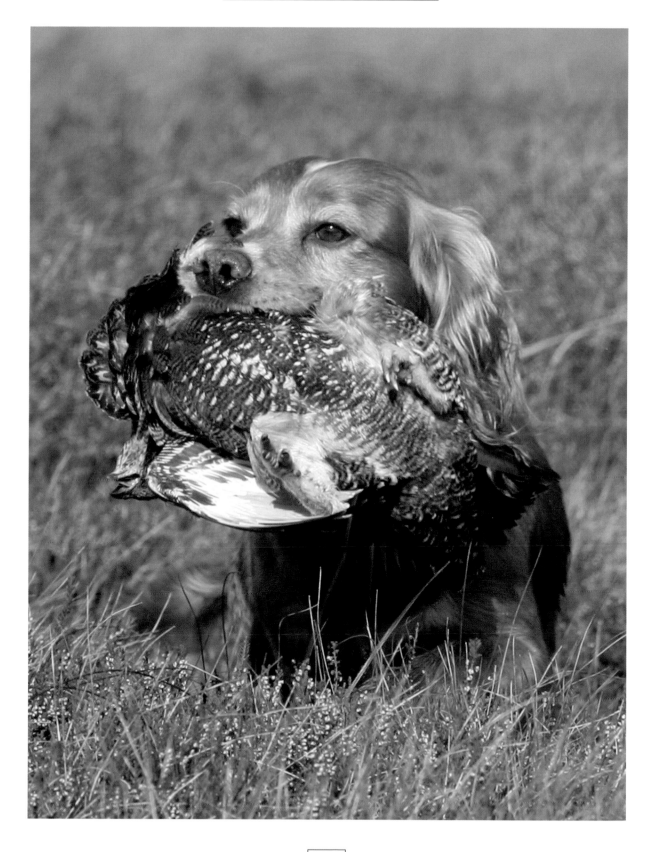

Those dogs worked so hard during that day and I could only imagine how difficult running through the heather must be for such short legs but as we returned back to the vehicles each and every tail was still wagging furiously in that typical Cocker manner.

One of the most exciting field trials I ever had the pleasure of covering was the 2005 IGL Retriever Championships, now you may be asking yourself …why is he writing about a Labrador trial in a book on spaniels? Well in that particular Championship for the first time ever spaniels were used in the line to flush game for the Guns and then the retrievers were used to find and return the shot game to hand.

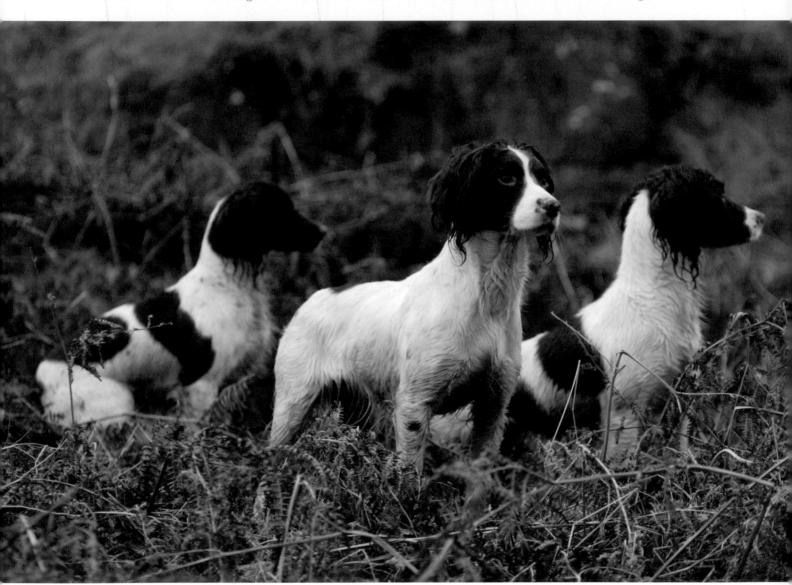

A team of Springer spaniels wait patiently during the IGL Retriever Championship.

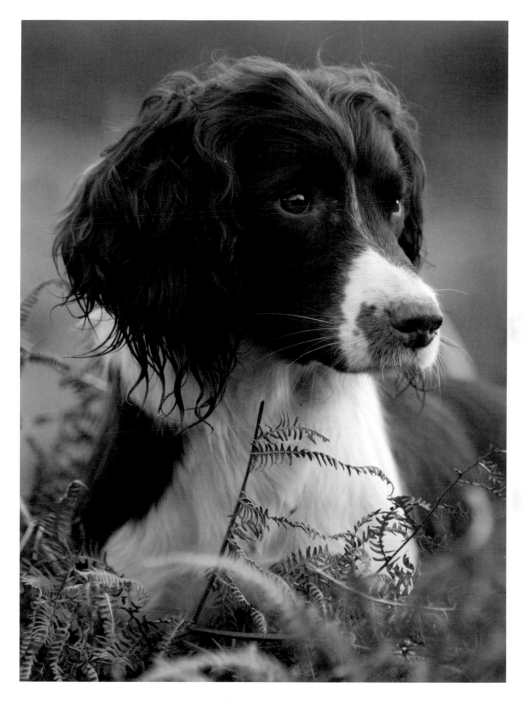

Another perfect flush

It was so exciting to watch the Springers and Cockers work in the line and I was spellbound as I watched the dogs hunt near perfect patterns in the laid bracken. I can remember walking along the top of a dell hole watching a couple of spaniels working in the bracken, they would punch their way underneath and then as a rabbit or pheasant flushed they would suddenly burst out and mark down the shot game.

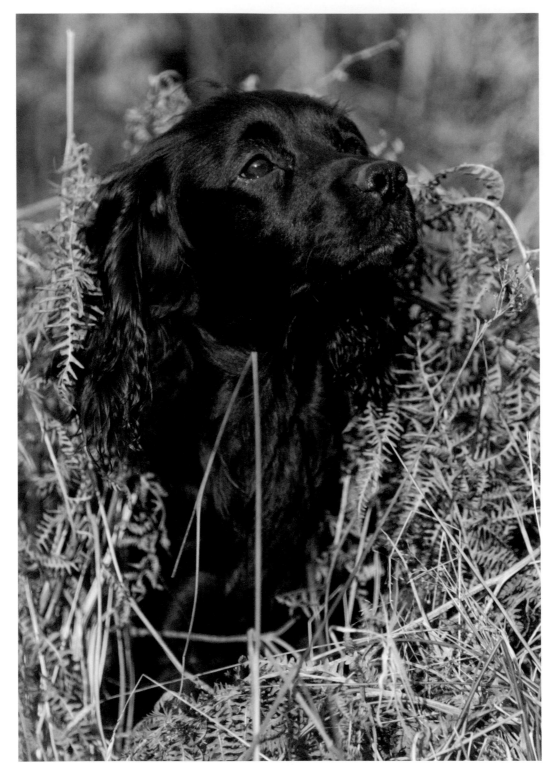

…watching the dogs working through the laid bracken was so exciting, especially when they flushed a rabbit or pheasant and then burst through the cover to mark the shot game.

Of course they were not allowed to retrieve anything and it was testament to all of the trainers that in the three days not one of the dogs ran in or indeed put a foot wrong. One particular handler was running three spaniels and he would hunt one whilst the other two walked to heel off the lead…have you ever tried to get just one spaniel to walk to heel? If you have you will appreciate that this is no mean feat especially as they had to watch the other dog hunting and finding game.

There is no doubt that a spaniel is the perfect rough shooting dog but in truth, especially in the UK it can be very difficult to get the opportunity of shooting over your own dog. Most shoots run either driven or walked up days and therefore spaniels are used in the beating line or as picking up dogs.

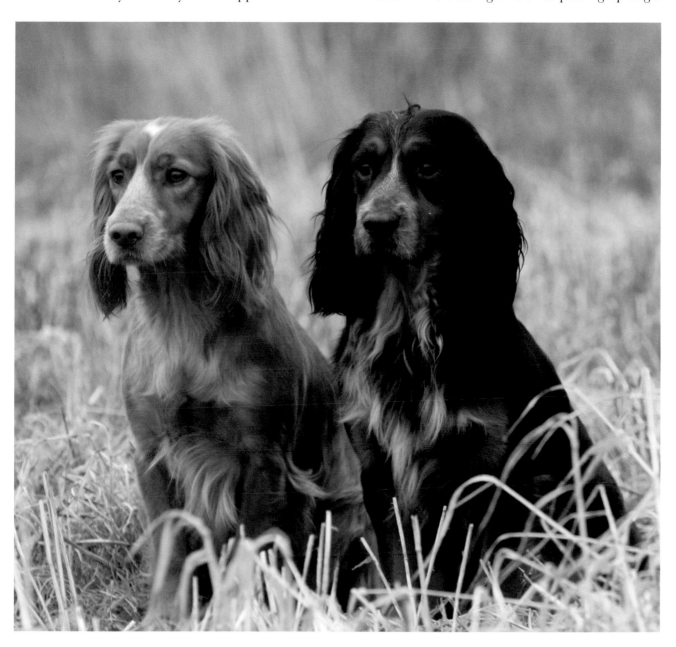

A nice looking pair of Cocker spaniels used as picking-up dogs.

At the time of writing this book Cockers are very much in vogue and there is a trend to have one sitting at a peg all day during a driven shoot. I have photographed a few spaniels that have been used as peg dogs and to me they always look miserable, it is almost as though they have had all the zip taken out of them, but come the end of the drive when they can get about and hunt up for a few retrieves they suddenly become a different dog.

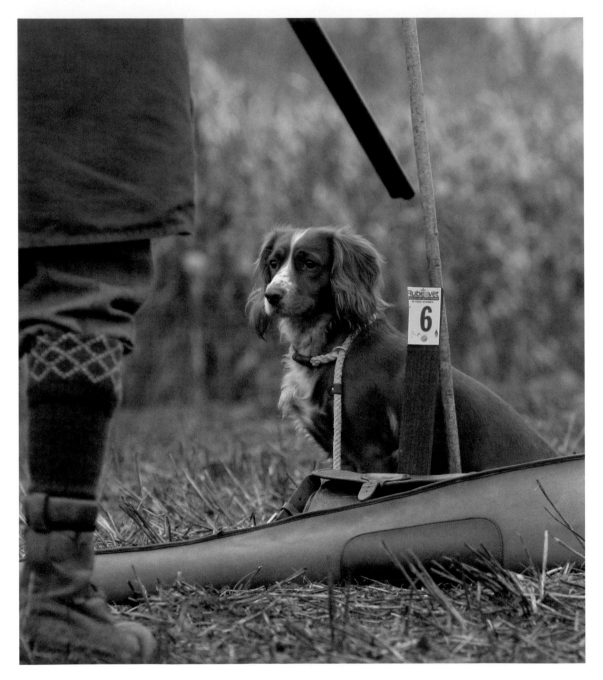

ABOVE AND OPPOSITE: I have photographed many spaniels used as peg dogs but to me they always seem a bit miserable.

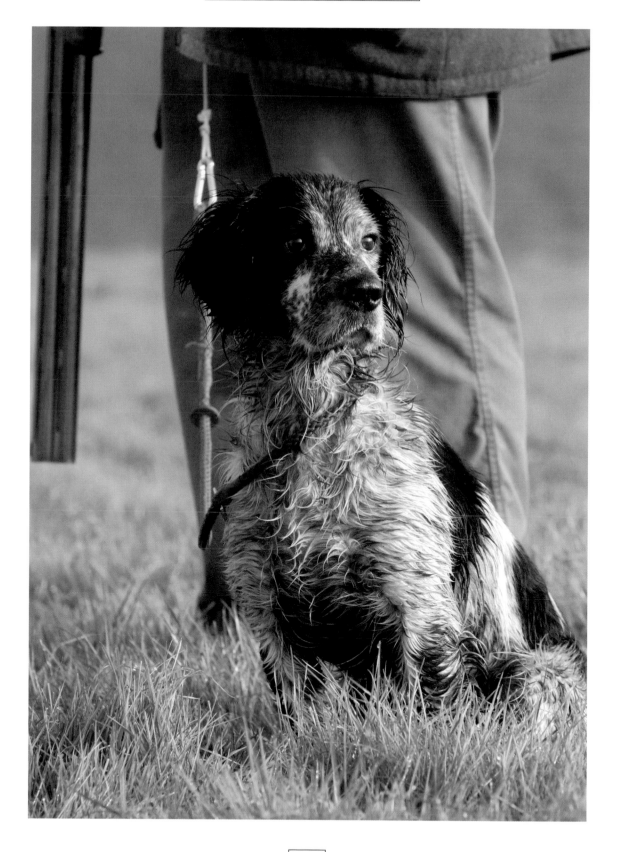

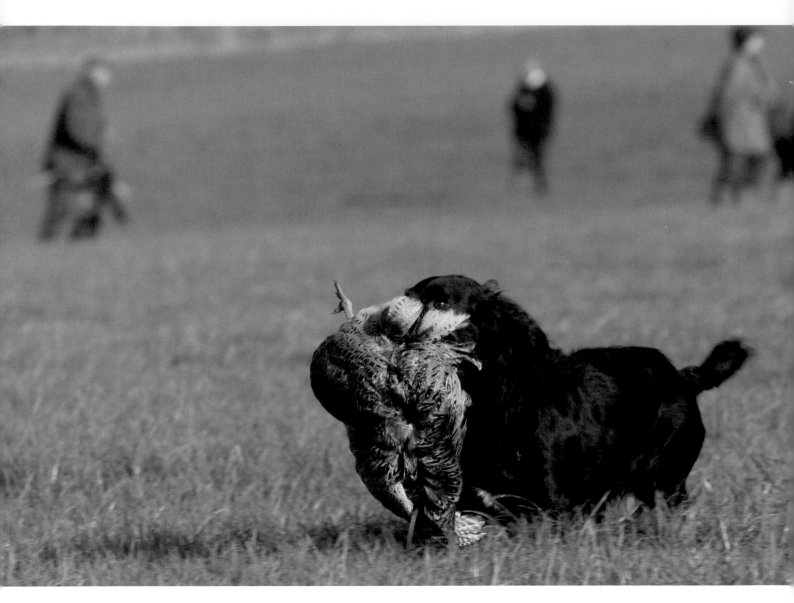

They may look miserable sitting at a peg but once the drive has finished they become a different dog.

Labradors or another breed of retriever may be the first choice as a picking up dog but I have witnessed some really first class spaniels in this role. After the birds have been flushed to the Guns and the drive is over the picking up teams sweep the area behind the Guns collecting the shot game. Whilst the retrieving breeds can pull off some wonderfully impressive long retrieves the spaniels tend to work in a closer pattern quartering the area and literally sweeping the area clear of shot game.

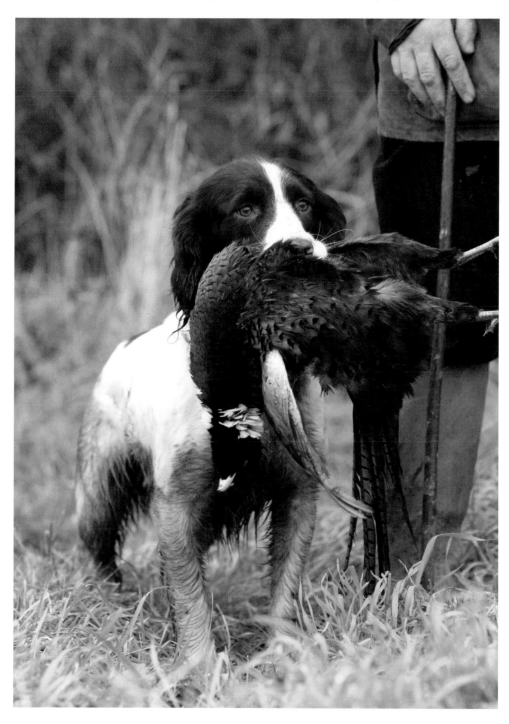

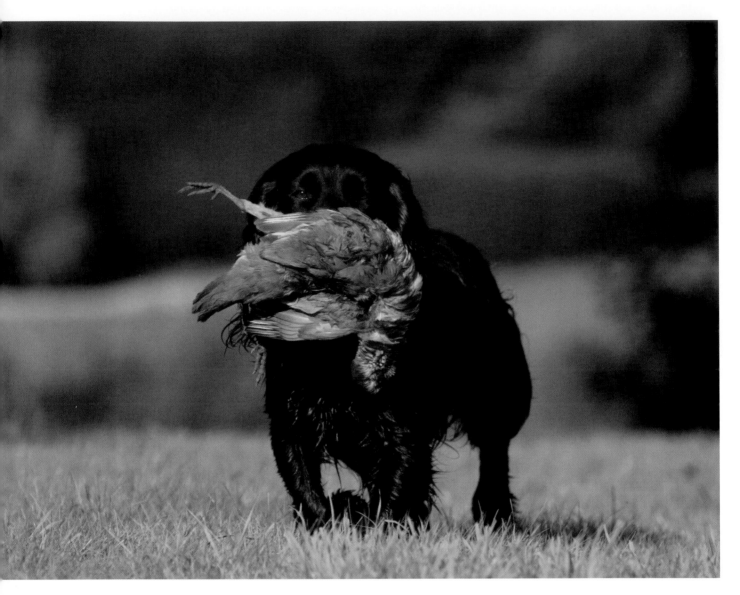

Spaniels can make first class picking up dogs as they literally sweep up after the drives.

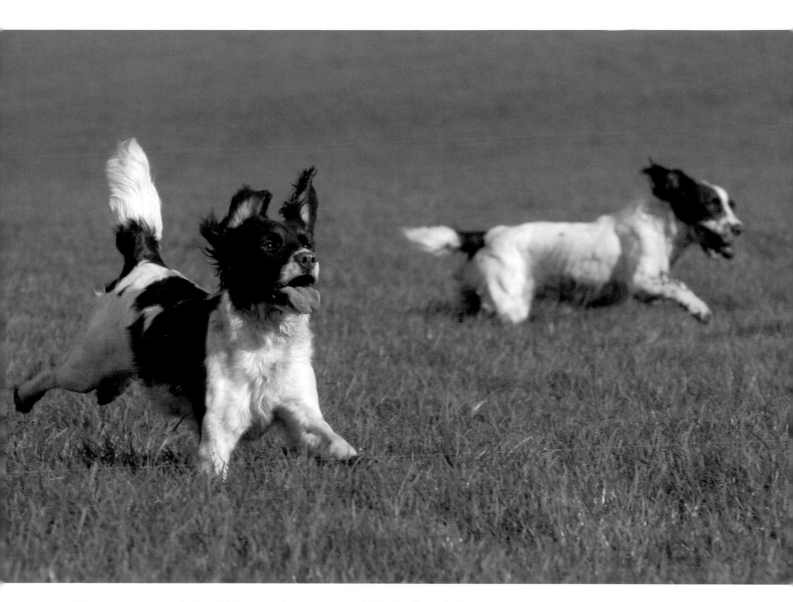

These spaniels may look as if they are charging around like headless chickens but they know their job and the best thing is they enjoy doing it!

They are particularly good at locating birds that have fallen into heavy cover, their power and tenacity has to be seen, especially when they are trying to get into a tight bramble bush.

Although the main function of a working spaniel is to find and produce game for the Gun to shoot they also have to find and retrieve the shot quarry and although no Gun wants to injure any animal it is a fact that occasionally a bird or rabbit will get shot but not killed and it is for this very reason we have gundogs. Many spaniels have the incredible ability to follow what is know as a 'line', this is the scent trail that is left as the game has run after being shot.

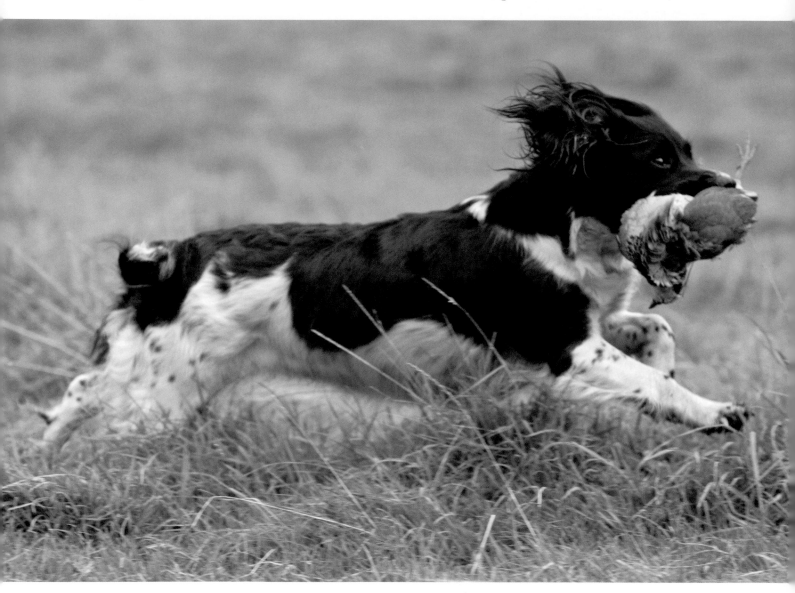

Many spaniels have the ability to follow a line of an injured rabbit or bird, and it is always a relief when they come running back with the retrieve.

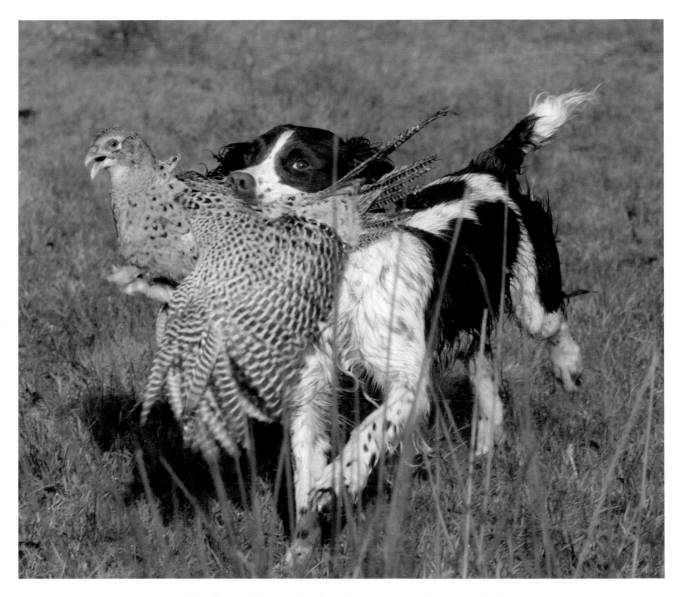

Watching a dog come back with a runner is always a relief.

To watch a dog follow this scent trail for perhaps sixty or seventy metres really is a thrill, although if you are the handler your heart rate really does increase as you have to let the dog 'do its stuff' and trust that it will not be disappear over the next hill never to be seen again! The feeling when the dog comes running back with the bird really is one of satisfaction, all the hours of training and the fact the dog has done a good job have really paid off, and of course it always helps if there are fellow handlers around to watch!

I think the one thing that I find so endearing about spaniels is that one minute you can be working a whirling dervish and the next minute they are snuggled up next to you sharing a quiet moment.

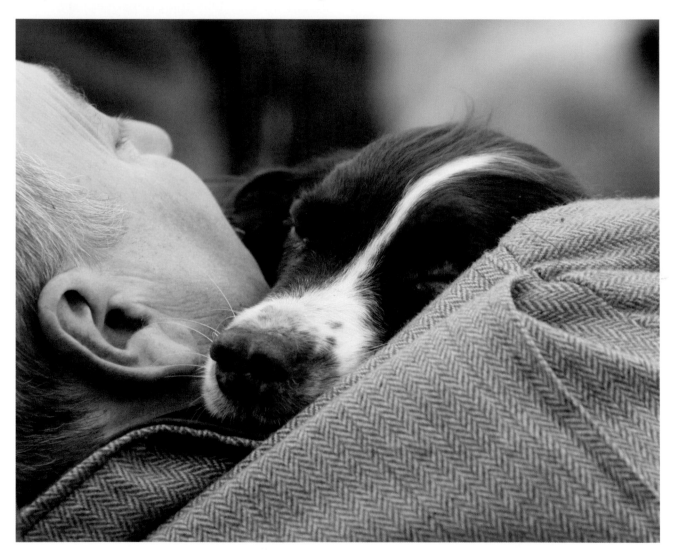

ABOVE AND OPPOSITE: The joys of owning a spaniel...one minute they are charging around like lunatics...the next they are snuggled up to you having five minutes doze.

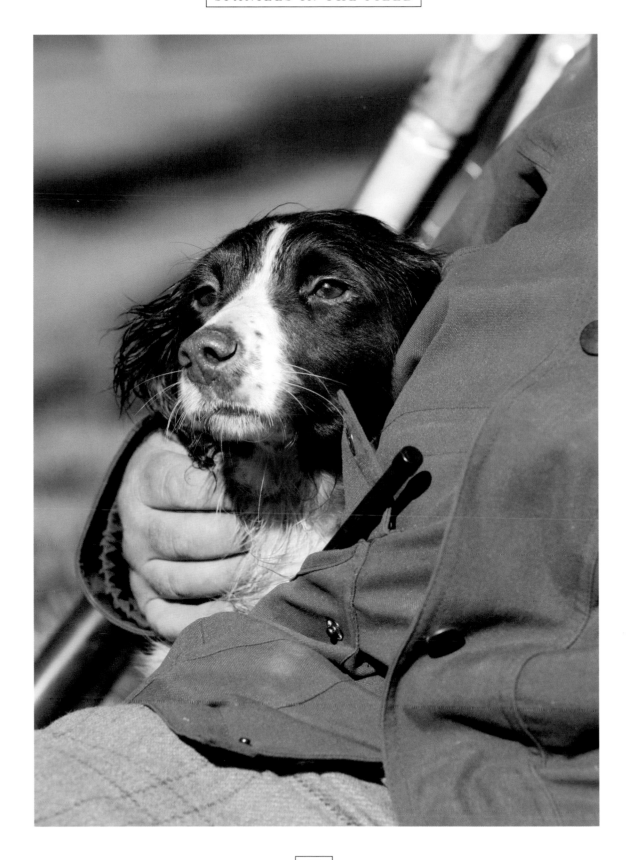

Although at times they will push you to the ends of your patience, there was an occasion a few years' ago when I was on a shoot in Somerset where I had been photographing a mixture of Springers and Cocker spaniels and one little golden Cocker had caught my eye. His owner was picking up and stopped for a chat and I took some lovely pictures of the dog looking up at his owner like only a spaniel can do. The sun was shining and the combination of the dog's colour, the green of the grass and the colour of the pheasants made a really nice image.

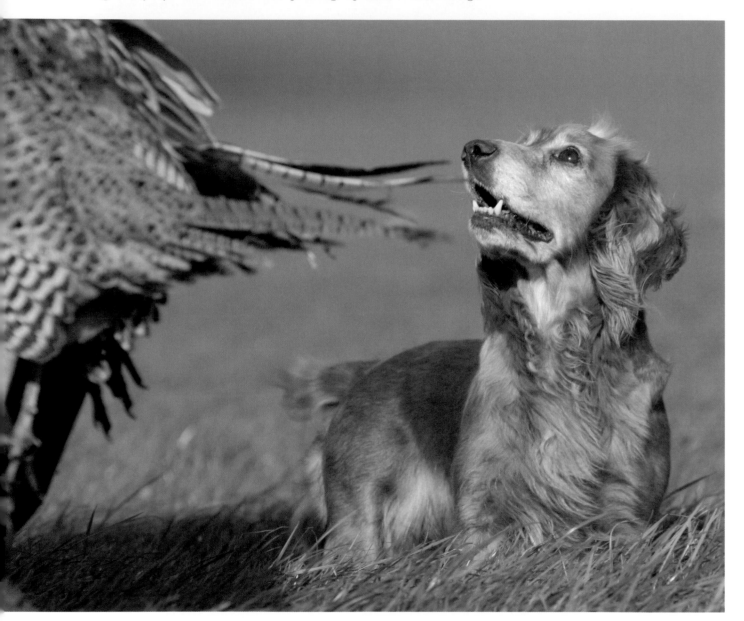

During a photo shoot in Dorset this little golden Cocker had caught my eye...

As I sat on the grass I could see the dog getting more and more fed up and after a while he wandered up the field to the gateway, which as we all know tend to be muddy places at the best of times. With a backward glance at his owner, who was still chatting away, the dog found the muddiest, smelliest puddle and lay down, I had trouble holding the camera still I was laughing so much.

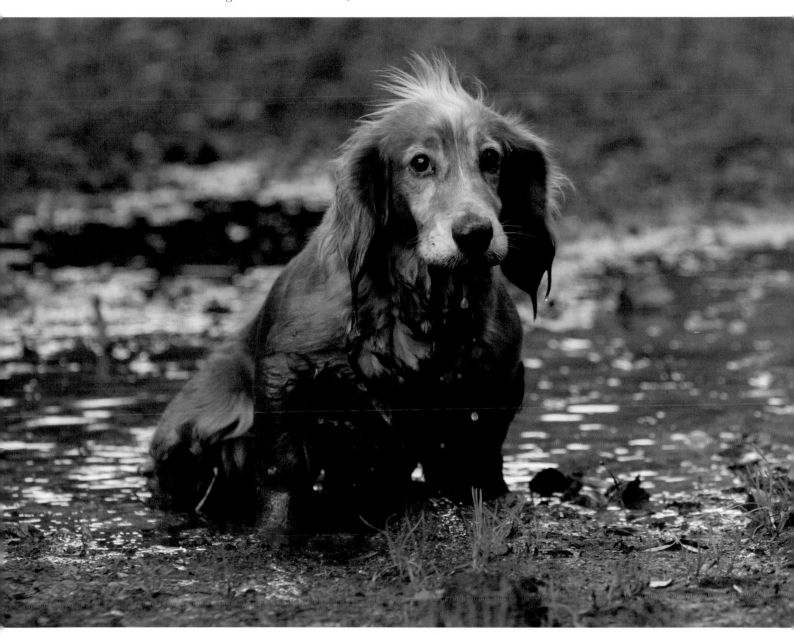

This image really doesn't need a caption – I think the dog's face says it all!

I recall Keith Erlandson in his book *The Working Springer Spaniel* referring to the Cocker spaniel as 'possessing a devilish sense of humour' and I think the dog's face in the picture not only confirms this statement as a very astute observation of dog behaviour but I think it also confirms it as an undeniable fact!

Before I leave the subject of spaniels working in the shooting field I must comment on their ability to jump, which for relatively small dogs never fails to amaze me. It seems to me that whether they are jumping over a fence, a fallen log or a ditch they just simply love to feel the wind in their ears!

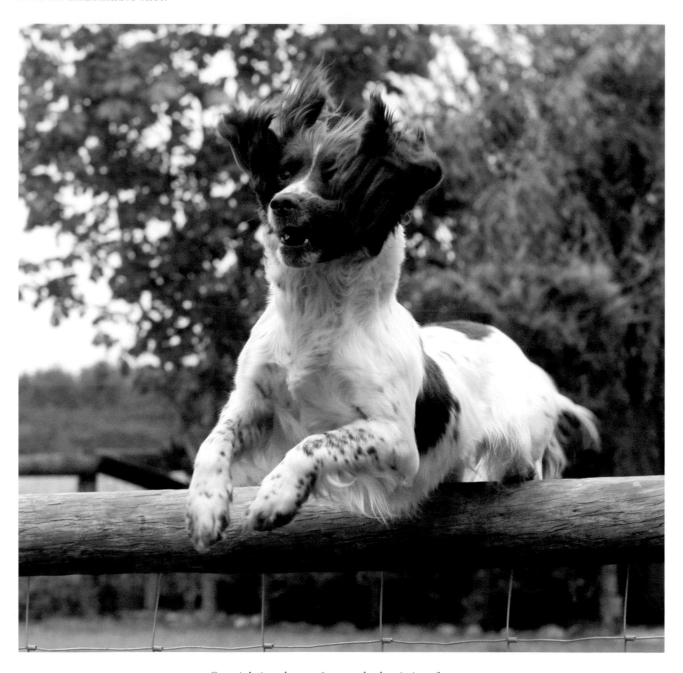

Spaniels just love to jump whether it is a fence....

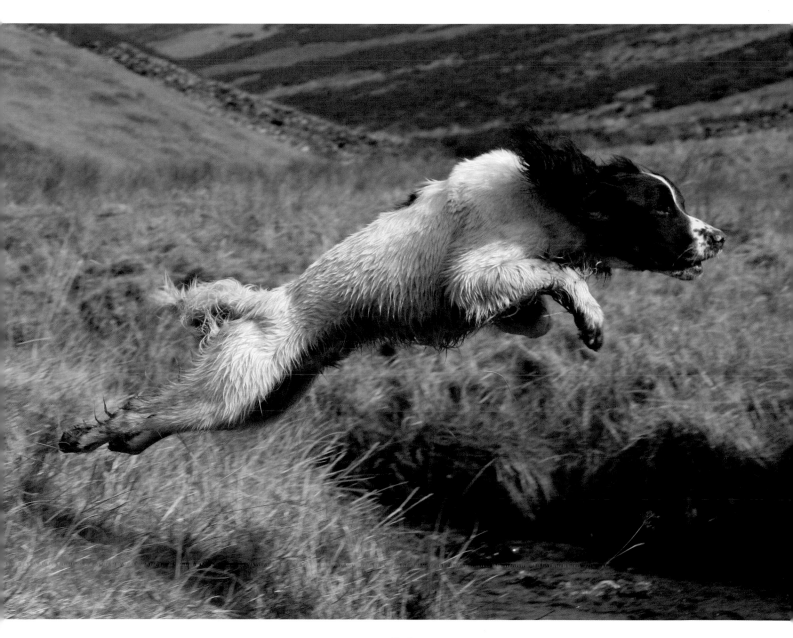

…a ditch…

I really do enjoy taking pictures of any dog jumping but there is something special about a Cocker or Springer flying through the air with a stupid look on its face that just adds something to the pictures. There are many people who own spaniels who never use them in the shooting field but they still put this natural ability to good use.

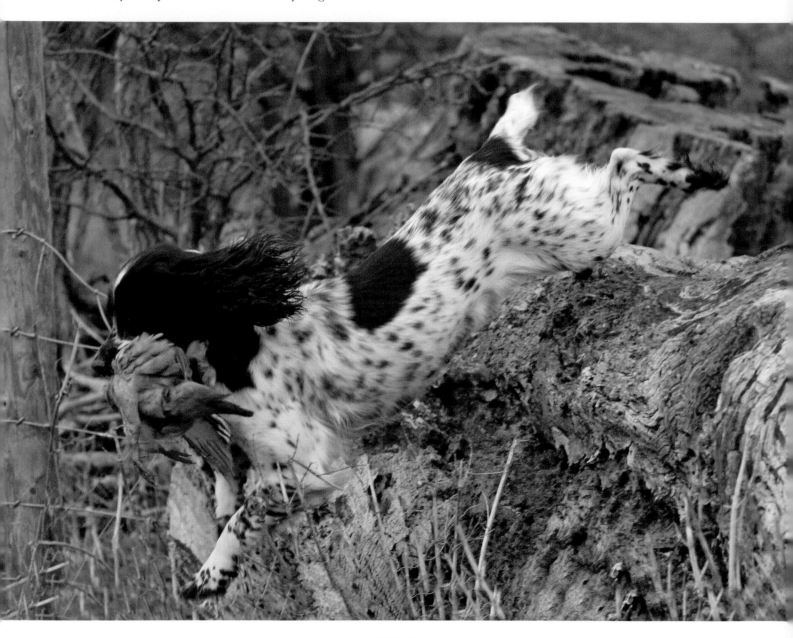

...a fallen log...

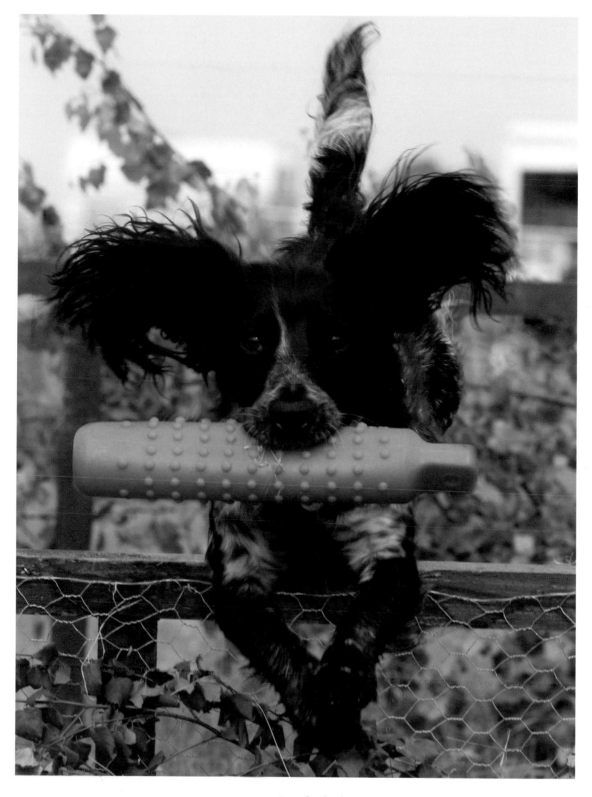

... or just for fun!

5 THE VERSATILE SPANIEL

Spaniels may have been selectively bred to work in the shooting field but nowadays they are extremely popular as pets, in fact Cocker spaniels have been second only to the Labrador retriever as the most registered dog with the UK Kennel Club for the past few years. As with most of the gundog breeds, Cockers and Springers make good family pets provided they get plenty of exercise and mental stimulation, remember whether you get a show or working bred line, spaniels thrive on being outdoors.

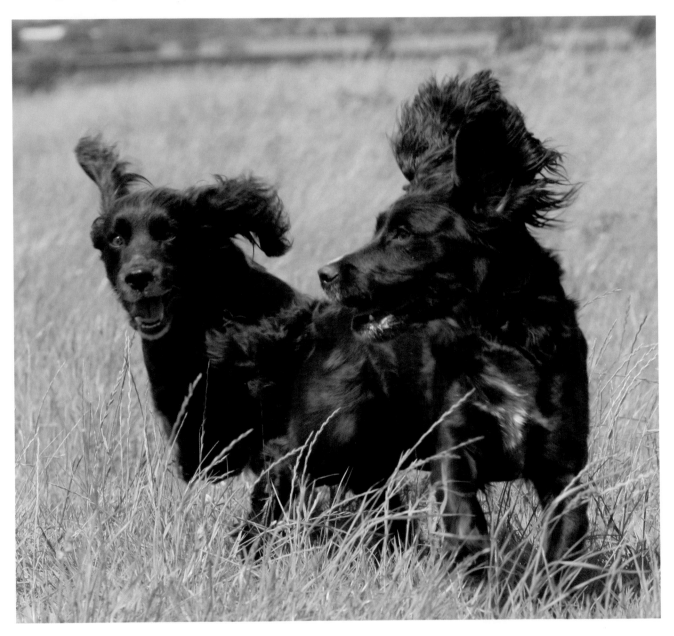

ABOVE AND OPPOSITE: Even pet spaniels thrive on being outdoors.

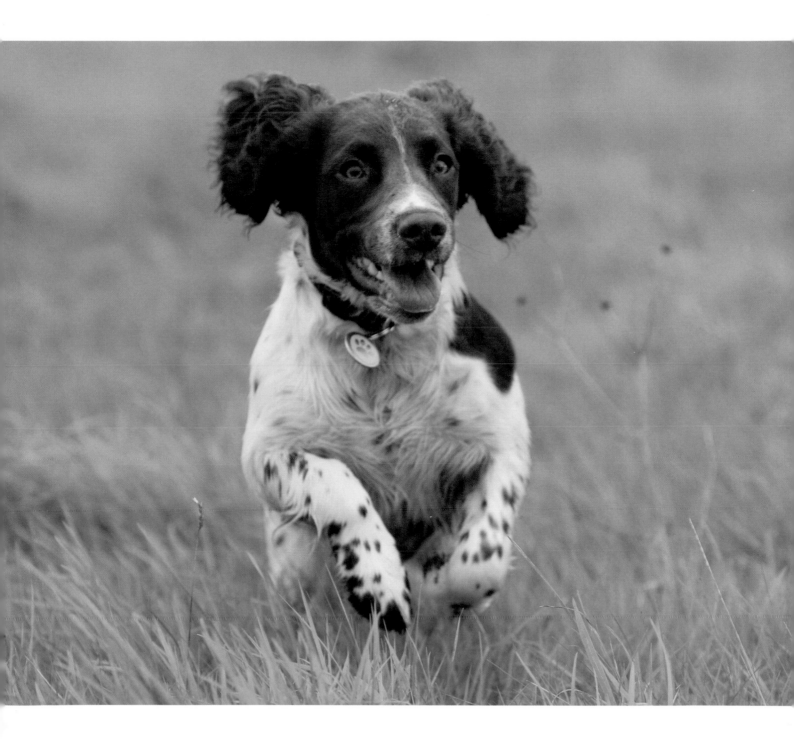

Over the years I have photographed hundreds of agility and flyball events and the increasing popularity of spaniels generally is reflected in these canine sports. Springer spaniels are very popular in the medium height agility events and do very well against the Border collies.

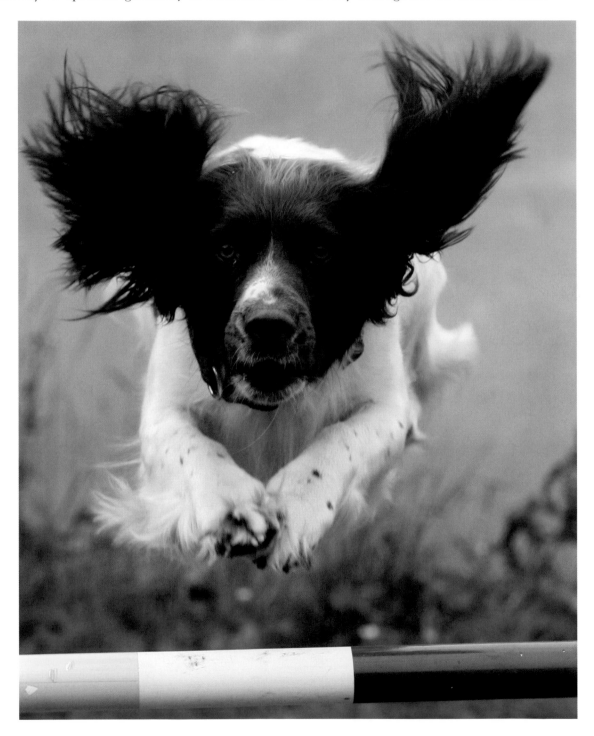

Springer spaniels are very popular in medium height agility events.

As with everything a spaniel undertakes running around an agility circuit is done with the utmost enthusiasm and passion, they sometimes seem to literally fling themselves over the jumps.

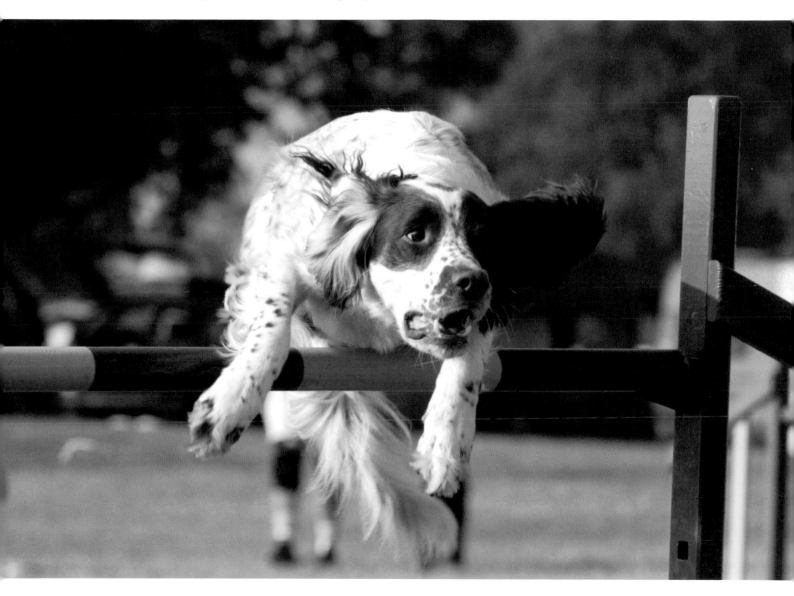

As with everything a spaniel does, jumping during an agility competition is done with the utmost commitment!

In the gundog world a dog that barks or squeaks is frowned upon and could never be used in a field trial, however in agility and especially flyball the dogs are quite vocal and at times it is quite amusing to watch the dogs seemingly shout at the handlers to run faster!

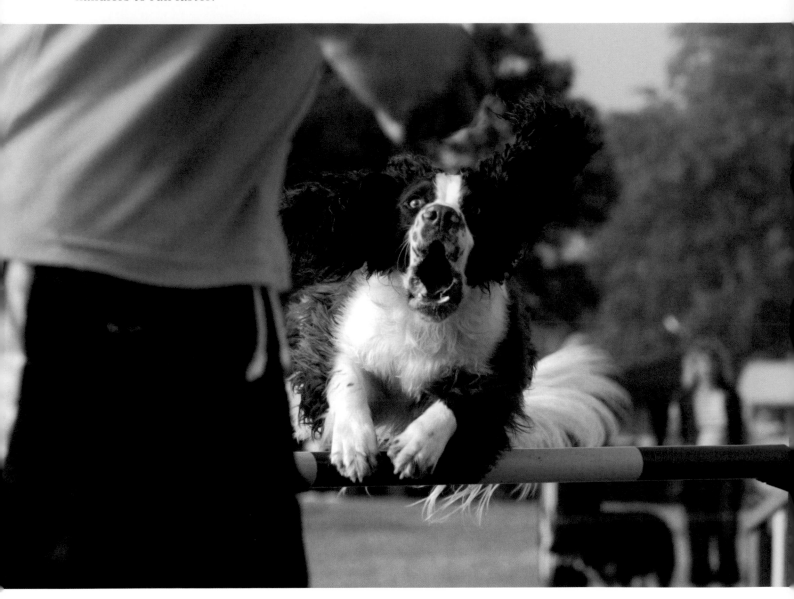

I am sure this Springer is telling its owner to run faster!

Of course ears feature a lot in my spaniel pictures and I am sure the dogs use them as mini air brakes or even as rudders so they can get around the course that much quicker.

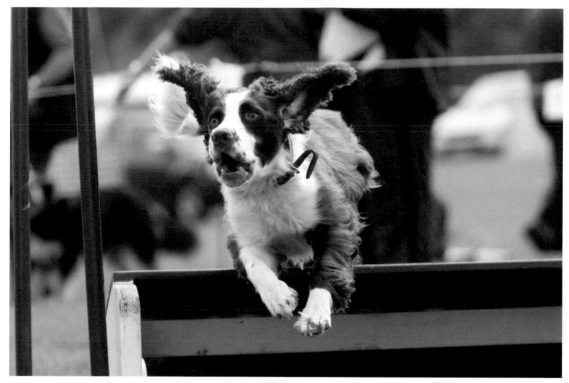

There is always plenty of ear action during agility…

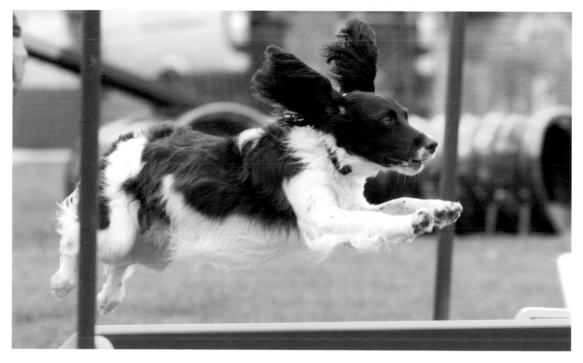

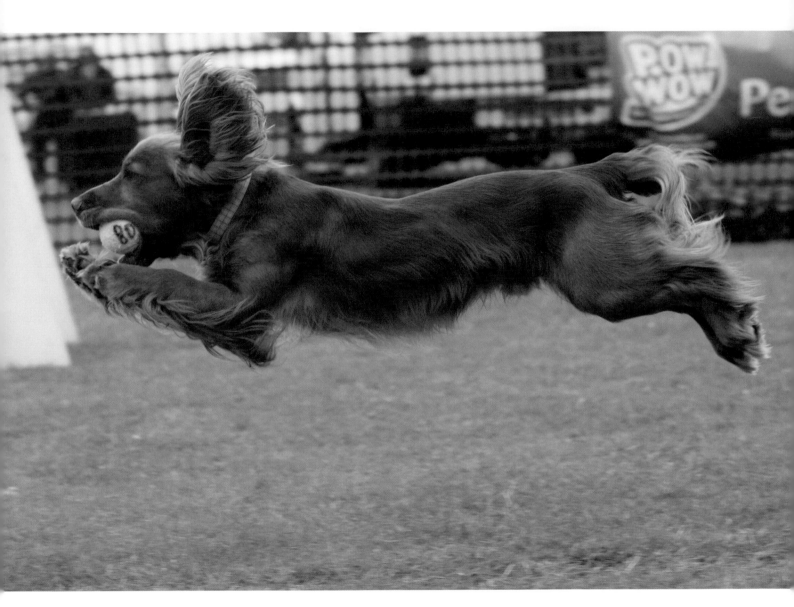

…and flyball.

In a strange way an agility circuit does contain the kind of obstacles that a spaniel may come across in the field. The jumps can represent a fence, the long jump is an open ditch, and if you use your imagination the weaves can represent the dog running through a plantation of young trees!

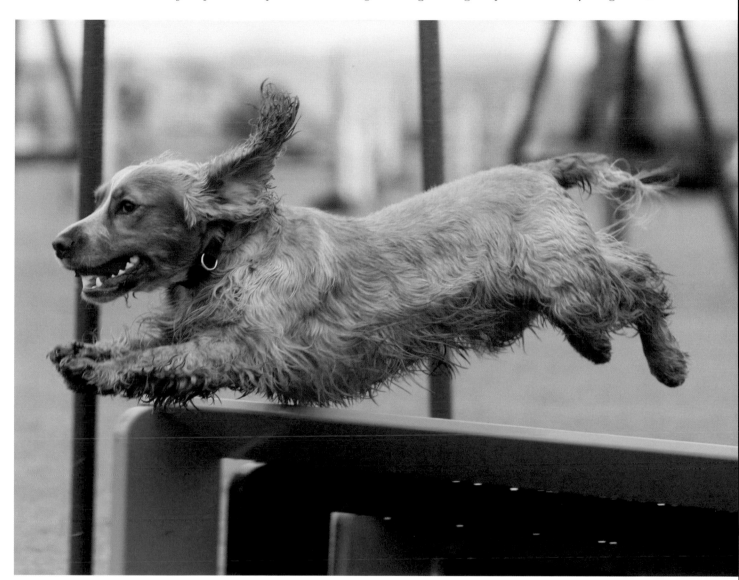

Some agility equipment can represent natural obstacles; the long jump could be an open ditch or small stream.

Photographically the weaves are the hardest piece of the course to photograph, a lot depends on which way the light is coming and also which side the handler is running. However if everything is in place it can be a great piece of apparatus to photograph. Experienced spaniels will skip through the poles and if my timing is right I can capture a good bit of ear flying and both front feet off the ground.

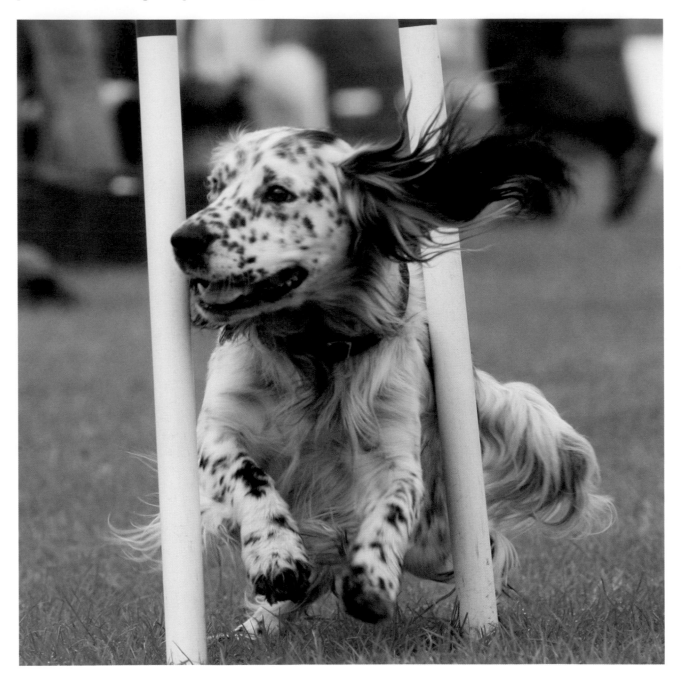

The weaves are the most difficult piece of equipment to photograph, but if I get it right I can get some ears flying and both front feet off the ground.

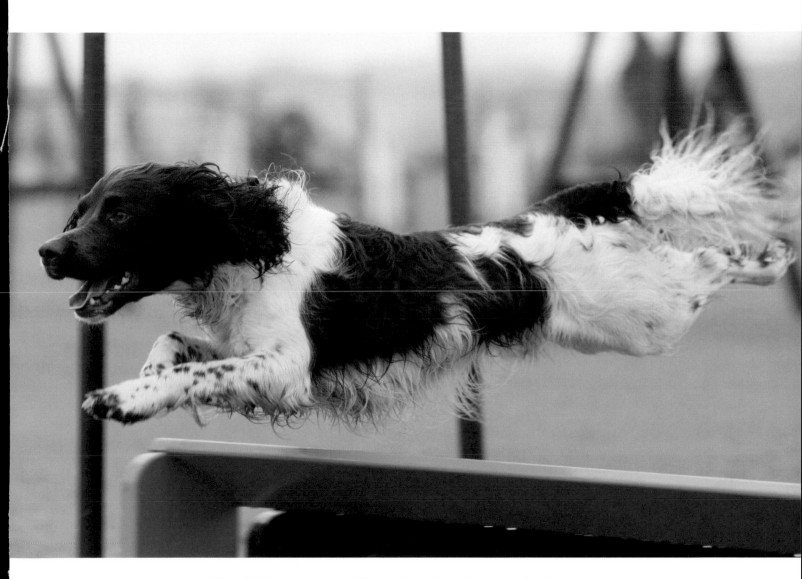

This Springer shows its agility and speed as it leaps over this long jump.

The long jump is always a good place for me to set up especially if the dogs are coming off a bend so they get a bit of swerve in their body as they leap over the planks. Most spaniels will jump very fast and very flat with their back legs straight out behind them and this is testament to the dog's incredible agility and their never ending enthusiasm.

One thing I can say is that I have never seen a miserable looking spaniel doing agility or flyball although I have seen a few despondent handlers if their dogs have gone a bit haywire…but that's spaniels for you!

Flyball is a fast and furious dog sport and working bred lines of Cockers have become very popular over the past few years and the smaller the better. The height of the hurdles is dictated by the height of the smallest dog in a team of four. Most teams will consist of a few collies or collie crosses and then a small dog; this could be a terrier or an ever enthusiastic Cocker. The aim is to get the hurdles as low as possible so the bigger dogs can simply step over them as they run down the lanes and of course the Cockers have a fine turn of speed and as already mentioned love jumping so it is the perfect combination.

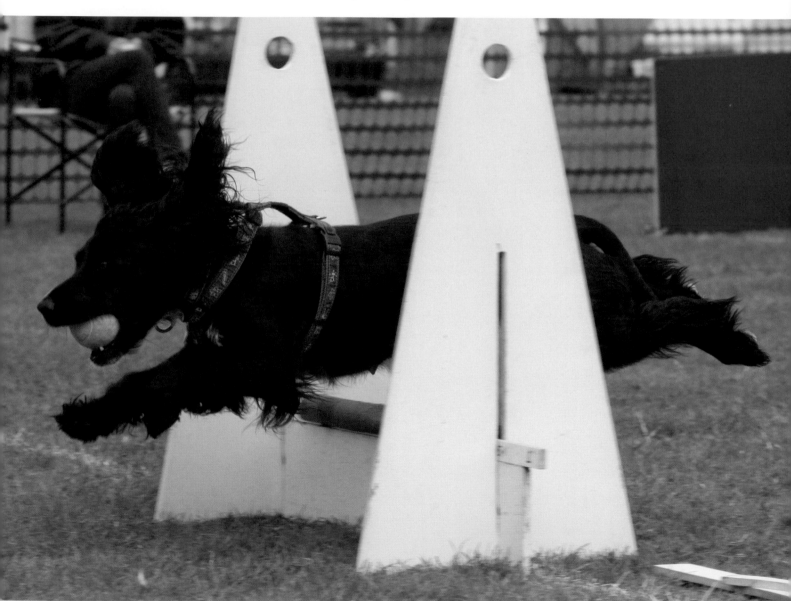

An enthusiastic Cocker in a flyball team is a real asset.

When the dogs get to the end of the hurdles they collect a tennis ball from a specially designed box and this of course ties in with the spaniel's love of retrieving so all in all it is almost a purpose built sport for non-gundog gundogs! Photographically flyball is one of the most difficult canine sports to photograph as it is fast and furious and there are literally split seconds to get the pictures.

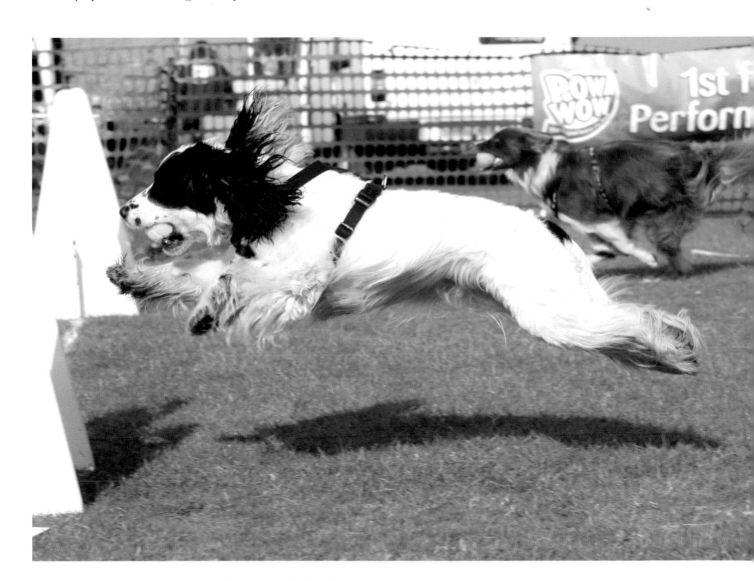

Photographing flyball needs split second timing...

In recent years I have been trying to get the dogs as they come running back with the tennis ball in their mouths, I aim to take the picture just as they jump for the hurdle and my timing has to be dead right or I miss the dog's head. The dogs only take a couple of strides in between the jumps and once my 'eye is in' I can consistently get the dog in mid-air just before it disappears behind the hurdle. I always feel sorry for the first few handlers as it can take me ten minutes or so before I sort my timing out but fortunately the teams run quite often so I normally get another chance at the early running dogs.

I would suspect that the vast majority of Springer and Cocker spaniels spend their lives as dedicated and much loved pets and they do excel in this role as a family companion. My own Cocker Sweep is the perfect example of a versatile spaniel; she is not a bad little gundog but she is just as happy lying upside down on the sofa having her tummy rubbed.

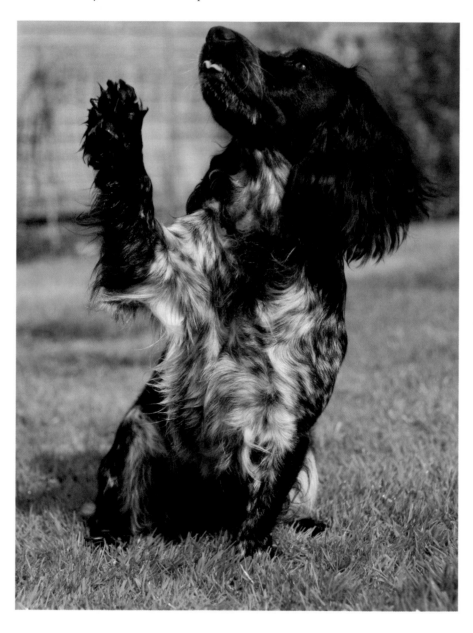

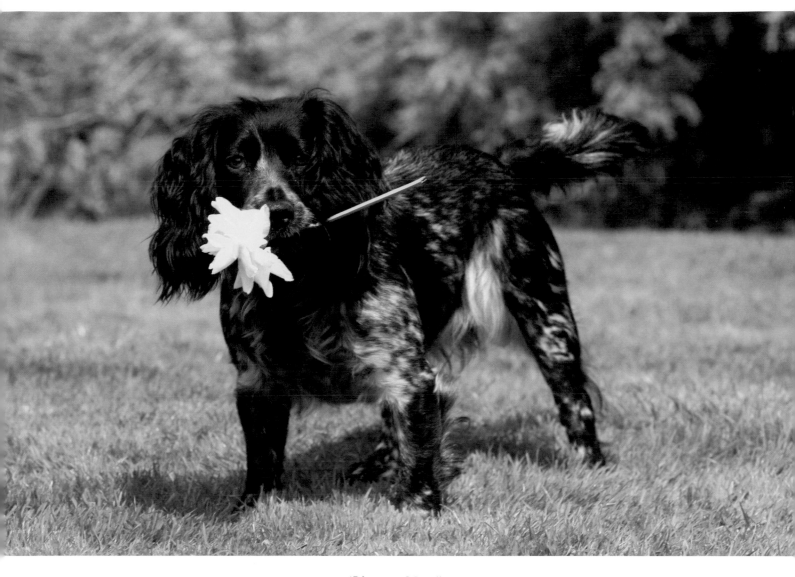

'I love my Mum!'

We have taught her a few little tricks and one of her favourites is to collect my wife's slippers when we get home, she can do a high five but one of the funniest things she has ever done is to present my wife with a daffodil. It was last spring and we had just got the new Cocker pup Harry and he was forever bringing in sticks, bits of mud and his favourite thing in the world…lumps of dried moss which the birds had plucked from the roof tiles. He loved to shake these and bits would fly all over the living room carpet making an awful mess, fortunately he has grown out of this annoying habit. Anyway on this particular day he had just prsented my wife with a dried and crumbling flower stem which I suspect he had retrieved from the compost heap and as with all potential gundogs he was getting praised and Sweep – not one to miss out on a bit of praise – came wandering up the garden path with a freshly picked daffodil.

OPPOSITE: Sweep has mastered the 'high five'.

I always have my camera handy and I managed to get a quick picture before she went in to the kitchen and sat down in front of my wife and presented her with the flower. I am not sure whether dogs can 'reason' but I am sure this really was a case of one-upmanship!

I mentioned earlier on in this book that I would suggest that of all pedigree dog breeds the Cocker and Springer spaniel are two that have very different strains...the working and show lines. If you were to put a working bred Springer and a show bred Springer next to each other, other than the colouring you would be hard pressed to see that they are the same bred, the differences between the two cocker lines is even more distinct.

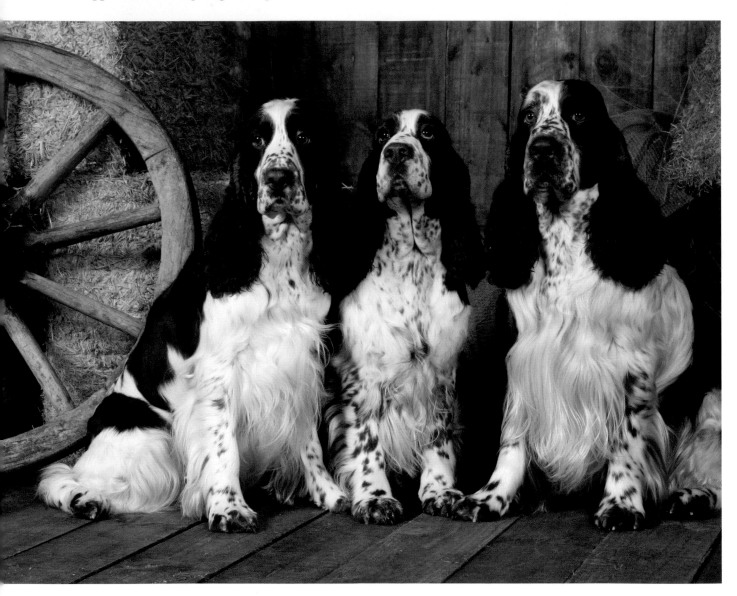

Three very smart looking English Springer spaniels.

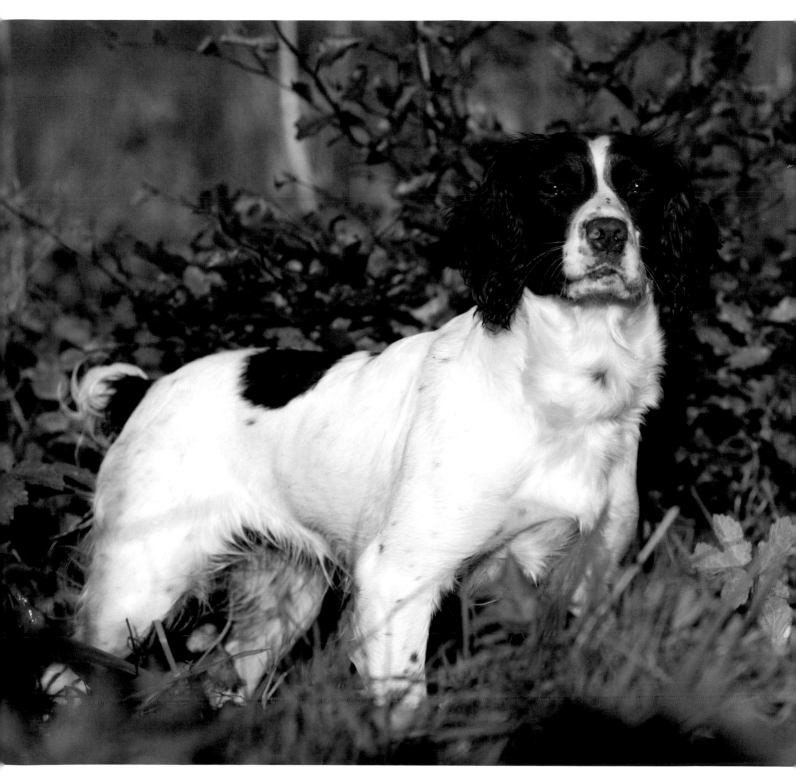

A working bred English Springer spaniel.

The show Springer spaniel has a more domed head with long ears and pronounced jowls; they also tend to be a much bigger dog. The show Cocker again has a more domed head and longer ears and in both cases the coat is longer.

A show bred golden Cocker spaniel.

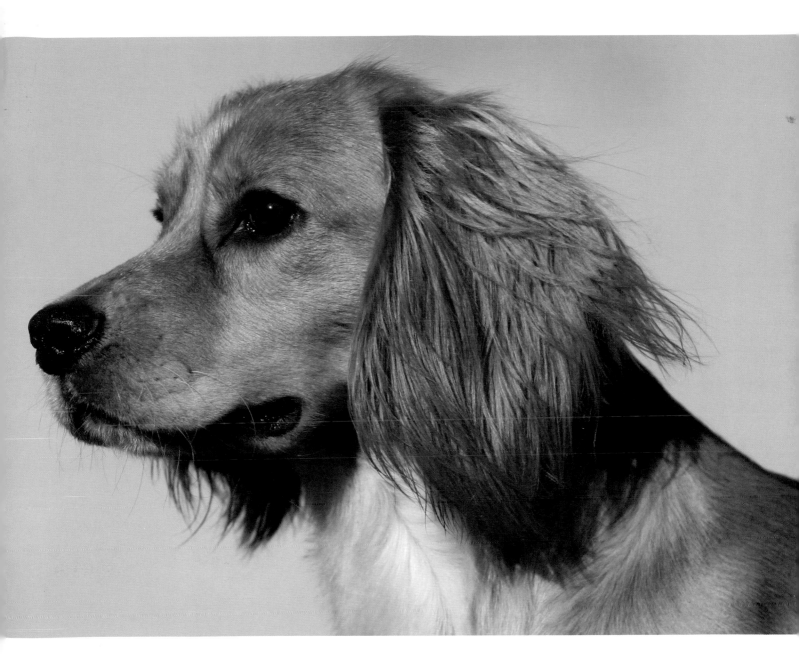

A working bred golden Cocker spaniel…the difference is not only in the looks.

6 THE PORTRAIT SPANIEL

Not all spaniels have a high action function many are simply loyal family pets and I see a lot of these dogs at the numerous pet dogs shows I work at during the summer months. I actually quite like these shows as I get to see a good variation of dogs and I do get to interact with them more than I do when photographing a shooting or agility event.

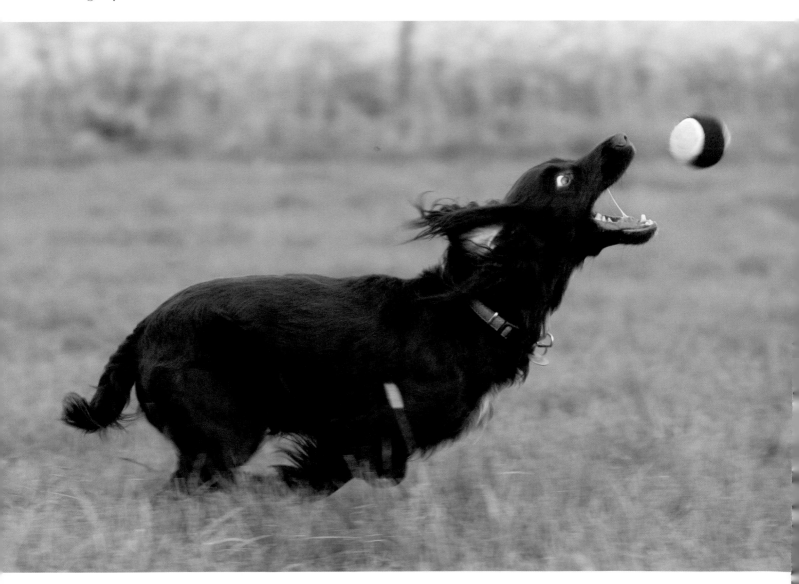

I like the pet dog shows we attend during the summer months and I can normally find some space to do a few action shots.

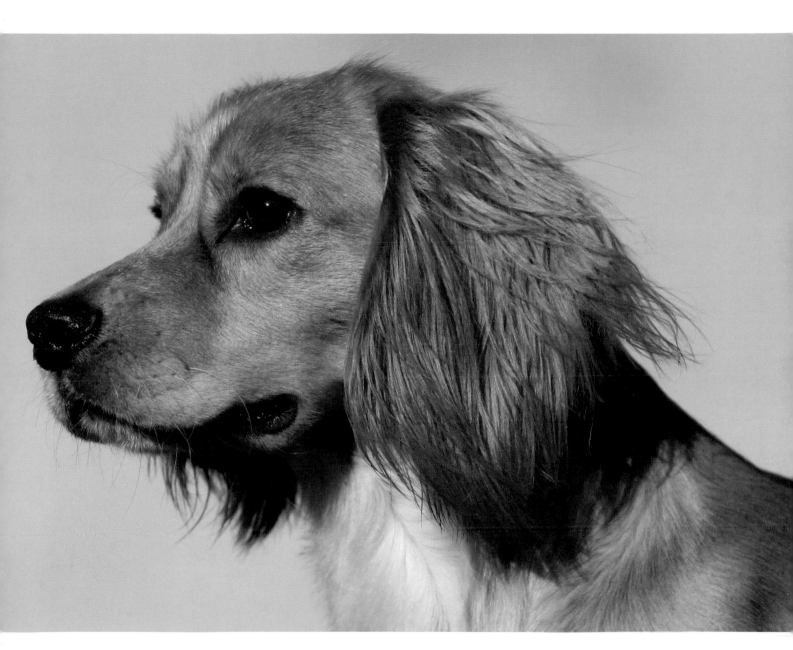

A working bred golden Cocker spaniel…the difference is not only in the looks.

For the past seven years I have worked at Crufts, the largest dog show in the world, and I always look forward to gundog day. The shooting season in the UK finishes at the end of January and Crufts is held in March so I still have plenty of visions in my mind of spaniels working in the field, getting muddy and wet and tearing through brambles and stick piles and then on gundog day I get to see the other side of the coin.

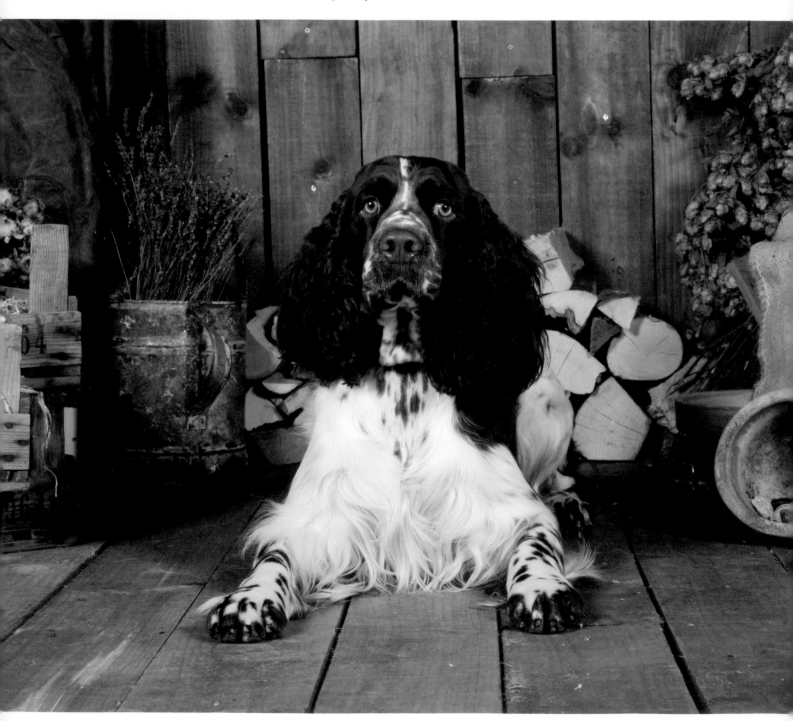

I normally catch the coach from the car park and it gives me time to take in the sights before I start work and I do chuckle to myself when I see Springer spaniels with full body coats and snoods around their heads to help keep their ears dry and clean.

I see plenty of Cockers in dog crates with wheels on being dragged behind their handlers and then before the showing they are getting brushed, trimmed and sprayed ready to be paraded around the ring. I am not going to get into the debate of what has happened to some of our dog breeds but I do sometimes think that those dogs would much rather be running around a muddy field with ears flying and jowls flapping doing the things that spaniels do!

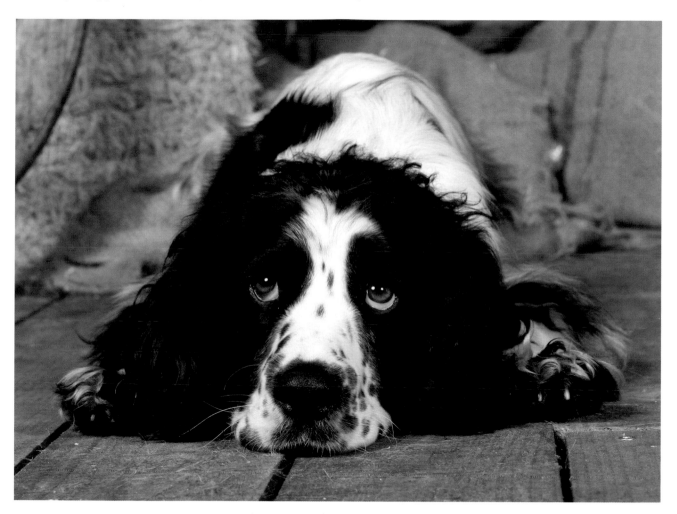

OPPOSITE AND ABOVE: Every year I work at Crufts and see plenty of show spaniels as well as some working ones.

6 THE PORTRAIT SPANIEL

Not all spaniels have a high action function many are simply loyal family pets and I see a lot of these dogs at the numerous pet dogs shows I work at during the summer months. I actually quite like these shows as I get to see a good variation of dogs and I do get to interact with them more than I do when photographing a shooting or agility event.

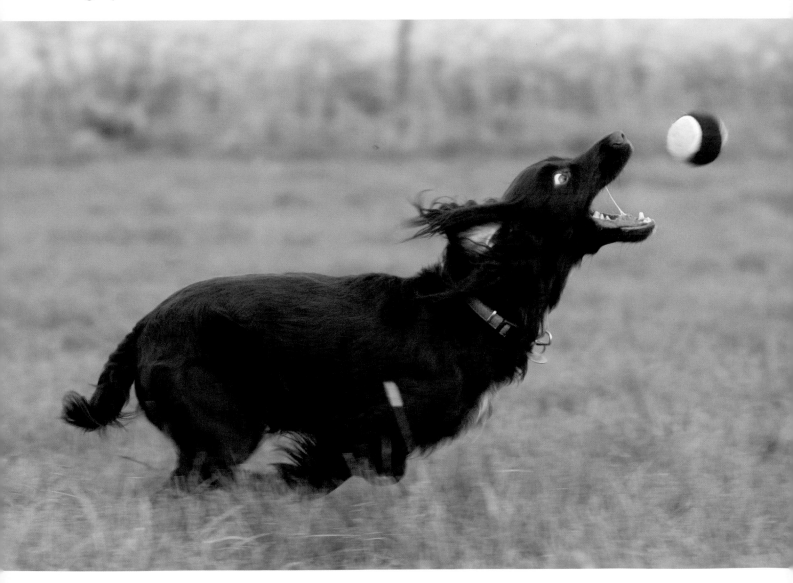

I like the pet dog shows we attend during the summer months and I can normally find some space to do a few action shots.

I normally try and find a bit of open ground where the owner can throw a ball for the dogs to chase but in many cases I just have to concentrate on 'straight' portraits. When I am taking photographs I always try and capture the character of the dog and quite often I will ask the owner if they have any little tricks or quirks that we could use.

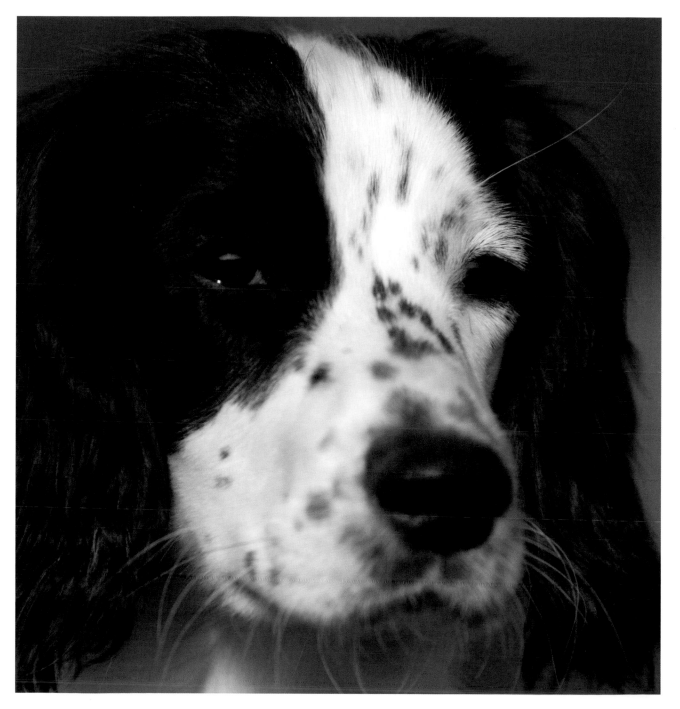

Sometimes I have to just photograph 'straight' portraits but I still try and capture the character of the dog.

One little golden Cocker that I photographed was deaf and its owner had to train it by the use of hand signals, at some point during its training the dog had decided to mimic its owner and it would sit down and raise one of its paws. The funny thing was that on every occasion the dog did this little trick he would stick out his tongue, it reminded me of a little lad at school that I used to know, who used to concentrate so much on his writing he would always have his tongue stuck out.

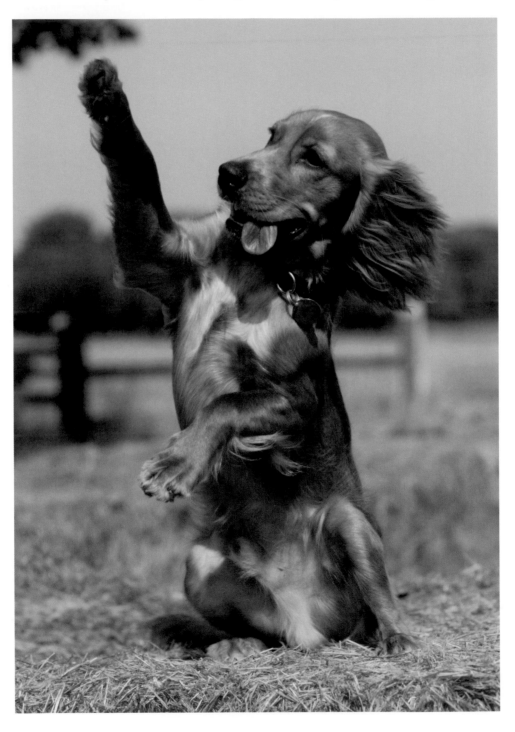

Trying to take pictures of more than one dog is always a challenge, you normally get one that will behave and one that wants to act the fool. Some years ago I was trying to take some photos of a couple of Cockers, in fact they were brother and sister and the male dog would not cooperate. After a while I managed to get them settled and just as I took the picture he looked at me but his litter sister was giving him such an old fashioned look! I put the following caption on the photo…'You are such a poser!'

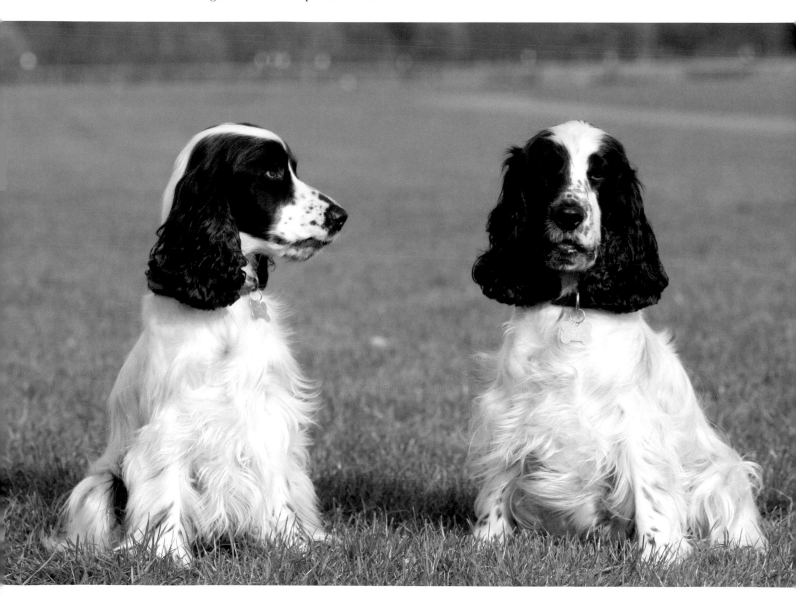

'You are such a poser!'

OPPOSITE: *I always try and see if the dog has any little quirks or tricks and this little Cocker always stuck out its tongue when it did a 'high five'.*

Even if I am just taking what I class as straight portraits I will still try and find or create a background that complements the dog and to me that means trying to achieve a backdrop that looks natural.

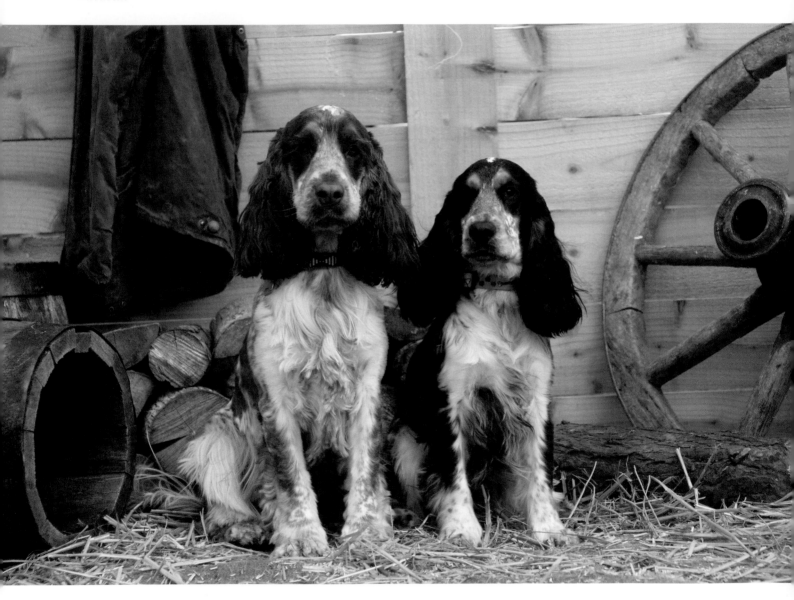

Even if I am at a big show I will still try to create a natural looking back drop.

OPPOSITE: *Despite the mud Rodney's tail didn't stop wagging.*

Anyone who has lived in the UK over the past couple of years will be all to aware that we have experienced some very wet summers and that has made it quite difficult at times to get nice portraits of dogs. At one show it rained on and off for most of three days and the show ground resembled a World War One battlefield. Rodney is a liver Cocker and he is totally obsessed with tennis balls and for most of the weekend he was backward and forward over the mud fetching his ball.

The general feeling throughout the show was one of despondency but Rodney's tail never stopped wagging and the muddier he got the happier he seemed to be! Although I don't mind taking 'still' photographs I always find myself looking for the opportunity to do some action images…it is what I enjoy! At one show there was plenty of space around our trailer and I was lucky enough to take a few of the dogs over for a run around. Watching and photographing spaniels running always brings a smile to my face they just seem to revel in the joy of running free. I know dogs can't actually smile but it does look as though that is exactly what they are doing or it could be as their ears fly upwards it pulls the side of their mouths into a kind of 'doggy grin' – well that's one theory!

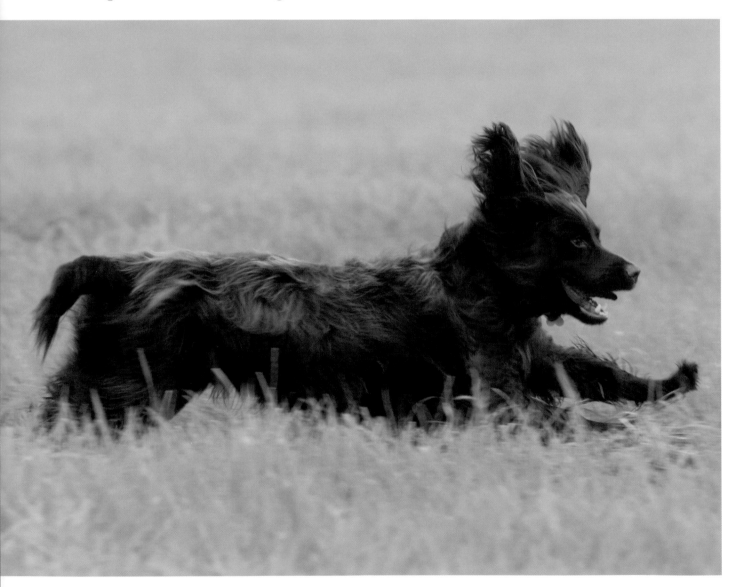

ABOVE AND OPPOSITE: I love taking pictures of spaniels running – they always seem to me to have a big grin on their faces…it may have something to do with their ears pulling the sides of their mouths into a kind of 'doggy smile'!

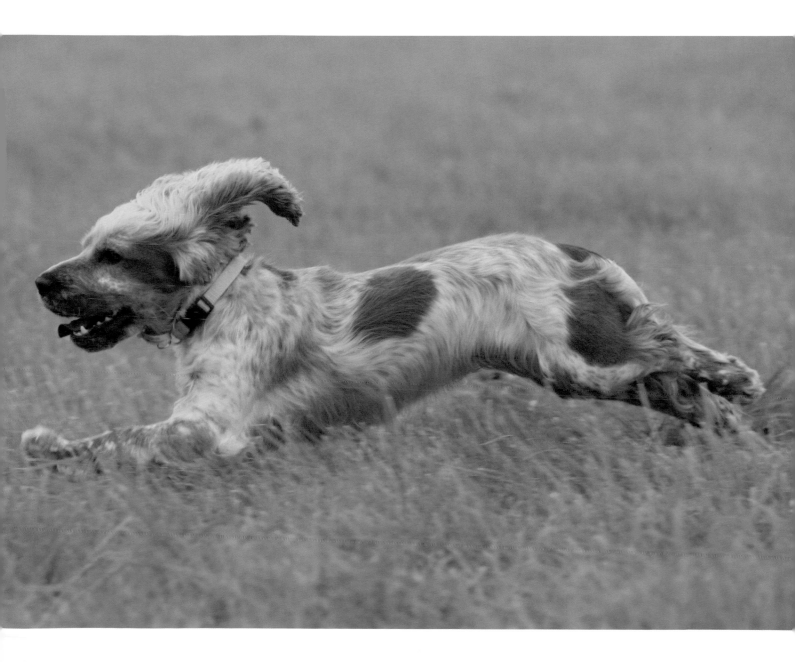

One of the most difficult shoots I had was of a black Cocker whose owner wanted my to try and photograph the dog in mid-air as it ran through a field of ripening wheat, and before people complain about trampling crops etc I must point out that the crop belonged to the owner of the dogs so it was her call! The dog would charge around and every now and again it would bounce up and take a look and then in a split second it would be gone again. I learnt a long time ago that by just standing and watching for a couple of minutes will always pay dividends and in this case it really did pay off.

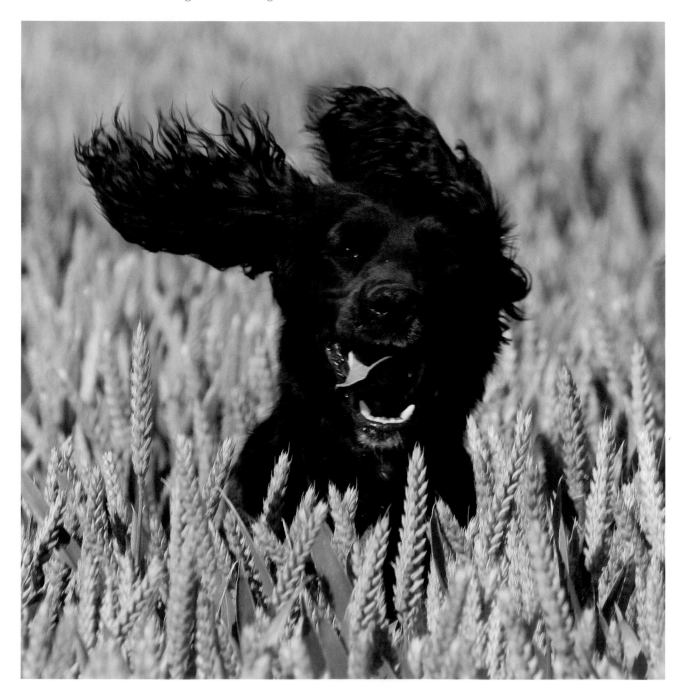

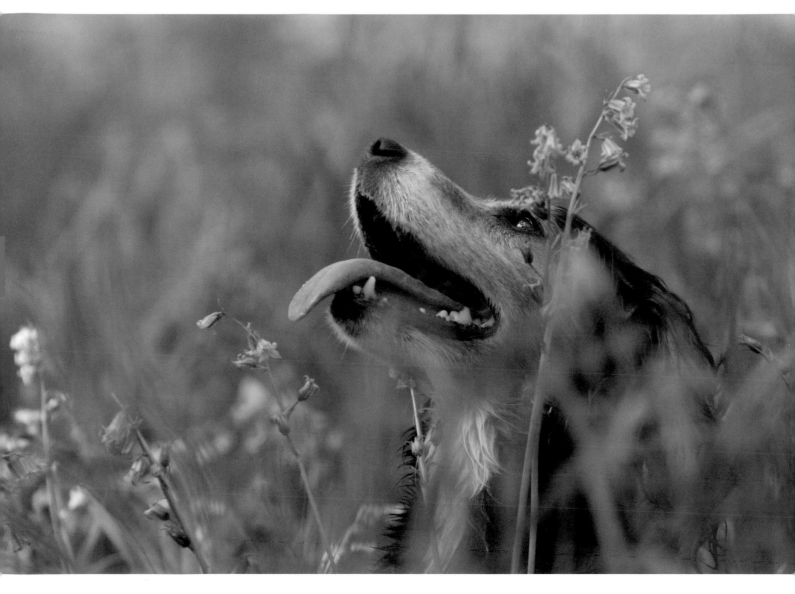

It always nice to find a few bluebells to use as a backdrop.

For most of the time I couldn't see the dog at all but I could follow its progress by the movement of the wheat. I worked out that if I tracked the swaying stalks and I was ready to hit the shutter button I could get a few pictures although I must admit my hit rate wasn't particularly good although the images that did work just showed what a great time this little dog was having.

My favourite time of the year to take images has to be spring and autumn, I find the summer light too harsh and most of the winter is too gloomy. During the spring months everything is so fresh and although I don't take what I would call 'twee' images it is nice to find a few bluebells in a sunny woodland glade.

OPPOSITE: Up periscope…just checking to see if you are watching me having a great time!

I was photographing the spaniels working in an old woodland and I was finding it quite difficult to get many shots as the cover was quite high but every now and again the dogs would stop and wait for directions from the handler and I was able to get some nice images. I focused on the eyes of the dogs and made sure the back and foreground was blurred and this gives the pictures a dreamy effect, quite different from the reality of the action that was really going on!

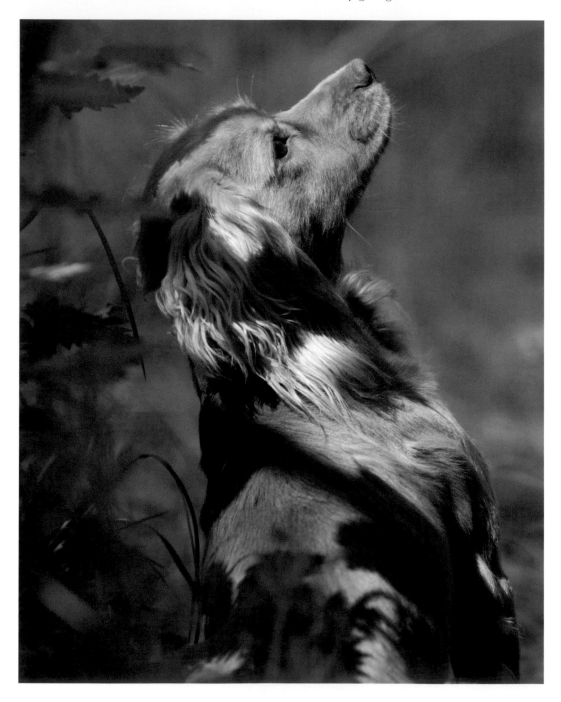

Total dedication…just give the word.

Despite spaniels living their lives in the fast lane there are times when they decide it is time to chill out and I am always on the look out for that moment when their heads hit the floor and they start to drift off in to their own little world. It's funny how different breeds have different habits, I have found that most spaniels will put their heads on the floor whereas Labradors tend to put their heads on their paws, it is not an exact science but it helps if you have a rough idea of what the dog may do.

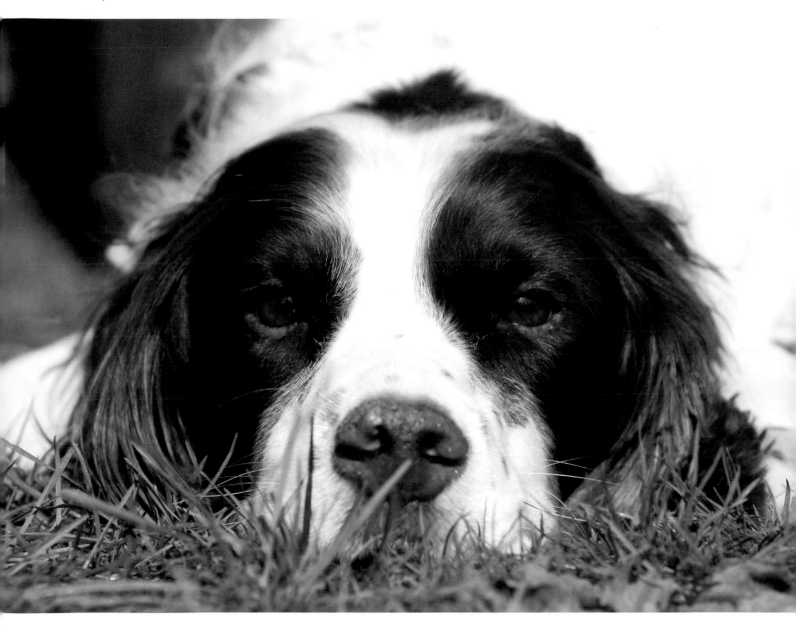

ABOVE AND OVERLEAF: Even a spaniel needs time to chill out…

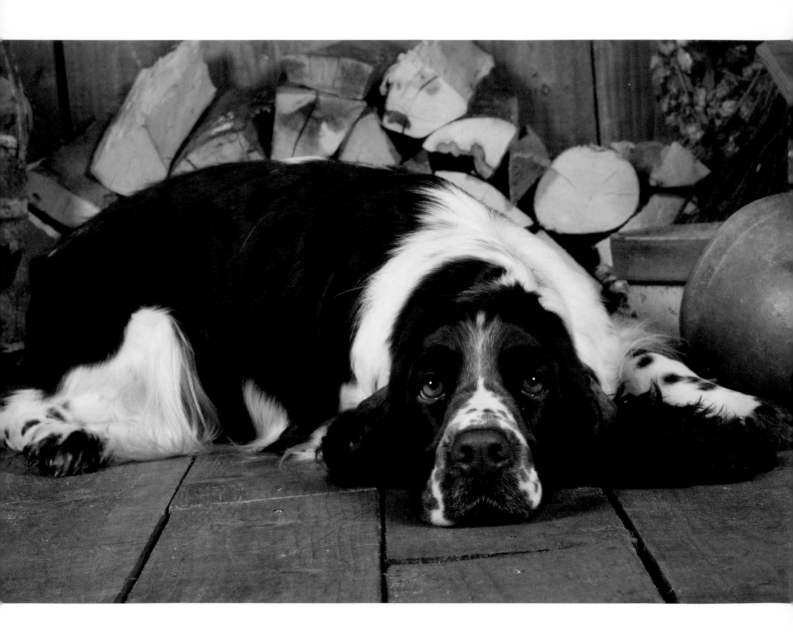

When a dog settles down it is amazing how many owners start to tell it to sit up, I have to be very quick to tell them to leave the dog alone I also have to be very careful that the dog doesn't come running over to me as I slide down on to my stomach to get absolutely level with the dogs' eyes…there must be an easier way of making a living!

When I come to the end of writing a book I always find it difficult to know how to finish it and to be honest I was struggling with an ending for this one but then the other night I was talking to a fellow gundog enthusiast and it dawned on me that this story would be a fitting end to a book on spaniels. I was telling him about a retrieve that my

Cocker Sweep had done the previous season and I then realised that I would remember this story for the rest of my life and I think it epitomises the whole essence of a spaniel, so I hope you don't mind if I share the story with you.

I was shooting on a walked up day when Sweep flushed a cock pheasant which I shot as it flew down the hedge line, although it fell to the ground straight away it did run so I immediately sent the dog. After what seemed like half an hour, but in truth it was probably about five minutes I could hear the yelp of a dog in distress, I started to walk along the track and the noise stopped. I had gone about fifty metres and then I heard a whimpering inside a thick bramble bush.

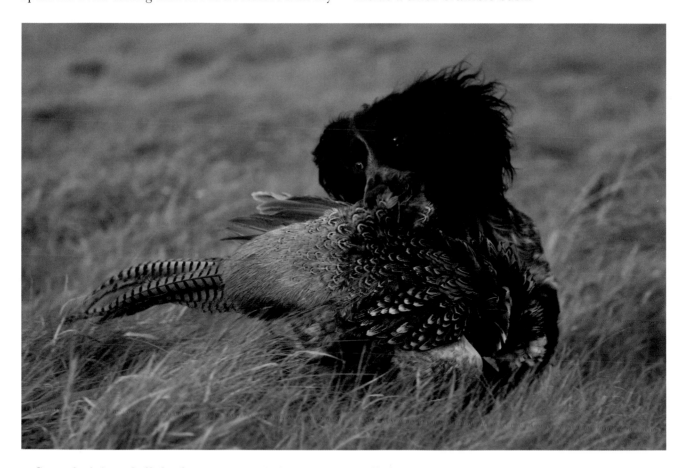

Sweep had showed all the characteristics of what a spaniel is all about…a big heart, tenacity, enthusiasm and most important of all a desire to please.

As I pushed my way inside I could just see Sweep up to her neck in a water-filled ditch, her ears had become totally tangled in the bramble and she was stuck fast and in her mouth was a very lively cock pheasant. I managed to cut her out of the tangle and she ran up the bank, had a good shake and then went back in the bramble and picked the pheasant and stood there with it in her mouth and her tail wagging furiously. I cannot describe how I felt at that time, I was as proud as could be, there were witnesses to this incident but it wouldn't have mattered if I had been out on my own with her. She had shown all the characteristics of what a spaniel is all about…a big heart, tenacity, enthusiasm and most important of all a desire to please, how good would it be if we as humans could take a leaf out of the spaniel's book!

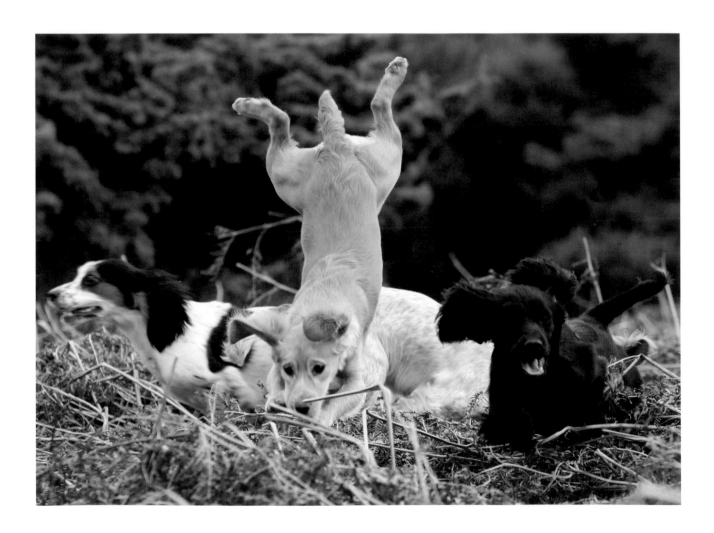

A working spaniel should have plenty of d(r)ive!